Remembering
Vermont

Ginger Gellman

T U R N E R
PUBLISHING COMPANY

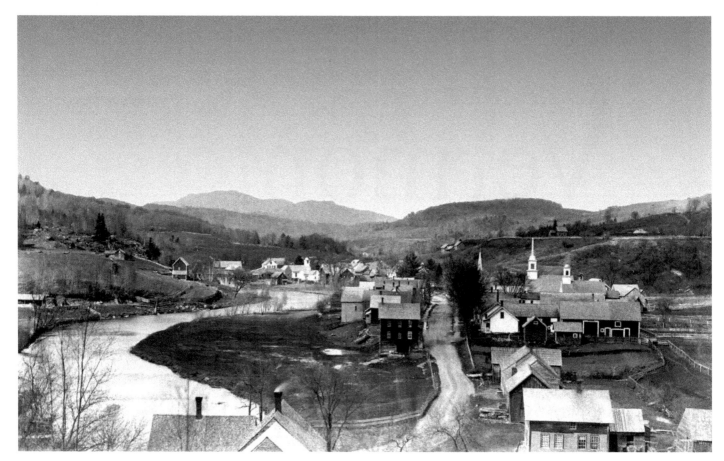

The village of Moretown on the Mad River. This view down Main Street shows a typical Vermont village scene after 1860. Moretown was primarily a community of farmers, and the central village existed to support the needs of locals with its churches, schoolhouse, mills, and artisan shops. Moretown shows us the quintessence of old Vermont: handmade, homegrown, and locally self-sufficient.

Remembering

Vermont

Turner Publishing Company
www.turnerpublishing.com

Remembering Vermont

Copyright © 2010 Turner Publishing Company

Library of Congress Control Number: 2010932281

ISBN: 978-1-59652-708-9

Printed in the United States of America

ISBN 978-1-68336-901-1 (pbk.)

CONTENTS

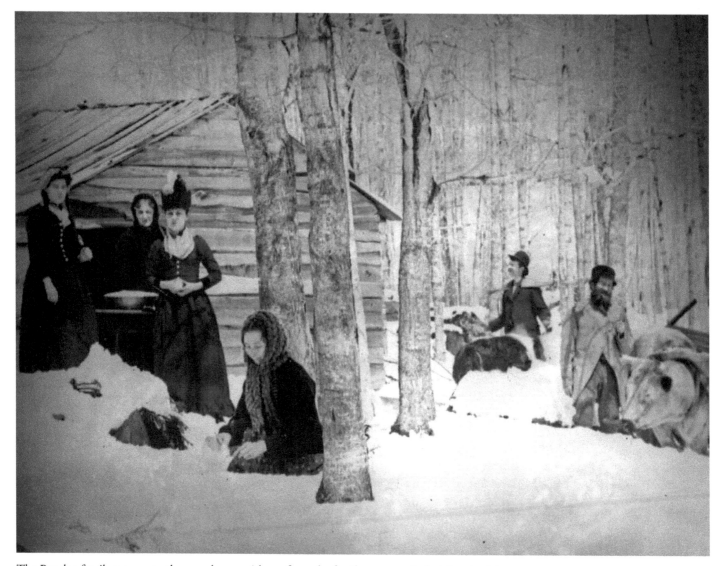

The Bentley family returns to the sugarhouse with sap from the family property in Jericho. At right, one relative dons his snowshoes and shoulder neck yoke, while another leads a team of oxen that are drawing a bobsled loaded with the sap tank. At left, the Bentley women prepare sugar-on-snow. Vermont's maple sugaring tradition dates back to the Abenaki Indians. As early as 1890, the state led the nation in syrup production.

ACKNOWLEDGMENTS

This volume, *Remembering Vermont*, is the result of the cooperation and efforts of many individuals, organizations, and corporations. It is with great thanks that we acknowledge the valuable contribution of the following for their generous support:

Bailey/Howe Special Collections, University of Vermont
Bixby Memorial Free Library, Vergennes
Brattleboro Historical Society
Bristol Historical Society
Cabot Historical Society
Jericho Historical Society
League of Local Historical Societies
Library of Congress
Floyd and Vesta McLaughlin
Moretown Historical Society

Noyes House Museum, Morristown Historical Society
Richmond Historical Society
Shoreham Historical Society
Shrewsbury Historical Society of Cuttingsville, Vermont
University of Vermont Landscape Change Program
Vermont Department of Libraries
Vermont State Archives
Jane Vincent
Williston Historical Society

Special thanks to Ginger Isham, John Carnahan, Christie Carter, Joann Nichols, and Gregory Sanford for their on-the-spot, save-the-day, quickturnaround answers to my many questions.

Finally, my heartfelt appreciation and admiration for Scott A. McLaughlin, for his outstanding and welcome ability to come up with the right phrase at the right time, and to make stories out of mere words.

With the exception of touching up imperfections that have accrued with the passage of time and cropping where necessary, no changes have been made. The focus and clarity of many images is limited to the technology and the ability of the photographer at the time they were recorded.

PREFACE

If you are one of those people who moved to Vermont in the last few years—and goodness knows there are many—then you have probably been dubbed a "flatlander" at one time or another. This is the term that longtime residents use when speaking of newcomers who were born outside the Green Mountain State. Perhaps you have chatted with your neighbor at a summer barbecue and listened to her count back how many generations her family has lived in Vermont. Conversations like these underscore the pride that comes with being a native "Vermonter."

These conversations also hint at the tensions given rise to by the influx of the many new residents who now call Vermont home. Many "flatlanders" were once summer vacationers who had purchased second homes in Vermont and eventually decided to live here. The result has been that the number of people in Vermont has increased by more than 200,000 since 1960, and state population growth has outpaced national increases for the first time since the early 1800s. Vermonters remember that, not too long ago, Williston's Walmart was a cow pasture and Interstate 91 was nonexistent. They remind us that a national chain store put their uncle's stationery shop out of business. With these dynamics in mind, it is no wonder that flatlanders have a bad reputation in Vermont.

Native Vermonters have long demonstrated the habit of rebuffing outsiders. The most familiar example dates back to Ethan Allen's Green Mountain Boys, who chased New York residents out of the region during the land disputes of the late eighteenth century. Even today, the Vermont Air National Guard carries the nickname "Green Mountain Boys" and has painted that moniker in billboard-sized letters on the Guard hangar at Burlington Airport. Vermonters have a history of warning outsiders to stay on their best behavior.

A similar insider-versus-outsider dynamic was evident in attitudes toward immigrants who worked in Rutland's quarries and Bennington's mills during the late nineteenth century. Tensions toward outsiders also rose against national labor union representatives, who stirred up political unrest in Vermont's urban areas. Objections to outsider intervention have been at times so strong that Vermonters have refused the intrusiveness of federal aid for local projects.

Over time, as more outsiders made their way into the state, many Vermonters dug in their heels and mounted defenses against whatever changes the outsiders might bring. They hugged more tightly a local identity rooted in traditional values. As Vermont hosted more foreign-language immigrants in the late nineteenth century, for example, Ferrisburg author Rowland E. Robinson memorialized Vermont's original dialects in his short stories. As Vermont's youth departed the state for better economic opportunities, towns put their histories on paper and hosted "Old Home" Weeks, reminding their departed sons and daughters of the rich Vermont heritage they had left behind. The result was that Vermonters gained a greater fondness for those things that signify old Vermont.

The idea of "Old Vermont" lives on, particularly in the state's tourism and marketing. Vermont-made food products such as maple syrup and handmade breads, covered bridges, and refurbished round barns have become the language for marketing the state. It is one of the ironies of old Vermont that today the state's heritage survives largely to satisfy the appetites of the outsiders who visit. Another is that changes to the state have indeed been wrought by the flatlanders, particularly in recent decades. It is the business of history to record such changes, leaving to posterity to sift the evidence for what may have been gained and what lost.

—*Ginger Gellman*

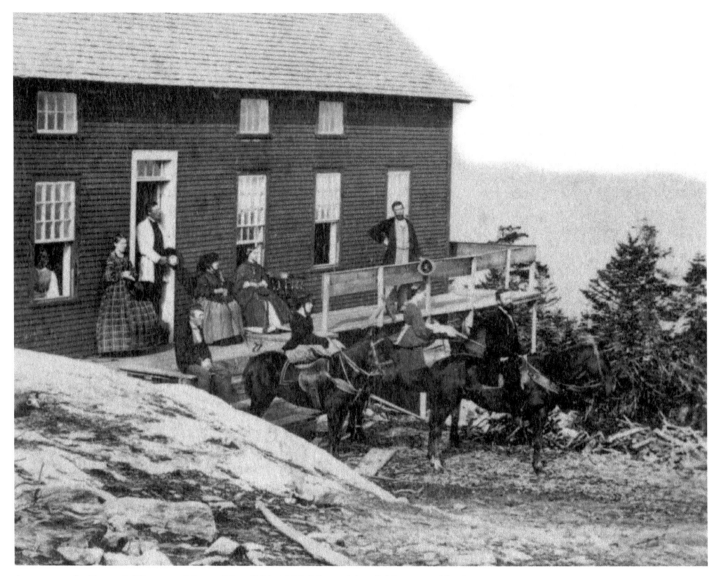

A group at the Summit House on Mount Mansfield, 1865. Mount Mansfield attracted business as a resort destination as early as the 1850s. A carriage road was built in 1853, and the Summit House, a "posh mountain hotel" situated just below the Nose, opened in 1858. A year later, the hotel owner sold the surrounding land to the University of Vermont—ostensibly to preserve a wilderness that helped attract out-of-state visitors.

OLD YANKEE COUNTRY

(1860–1899)

A camping party rests on Lake Memphremagog's Long Island in 1865. One of 15 islands on the Canadian side of the border, Long Island was a favorite resort area, particularly during blueberry season. A guidebook of the era advised female visitors not to dress "in a gorgeous way" when coming to the region to hike or boat, since "the worse you attire, the better you'll feel."

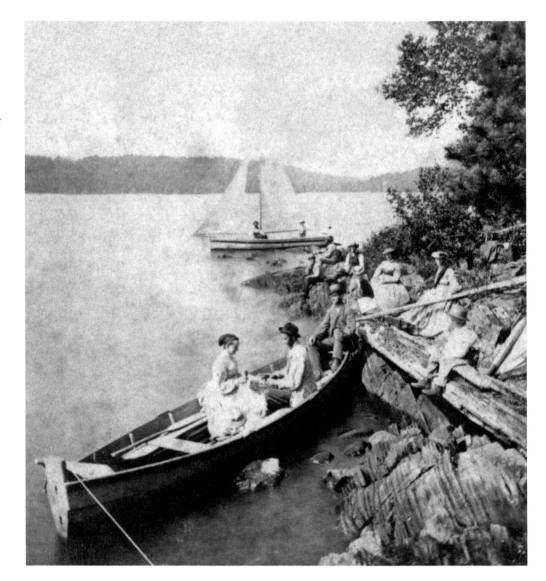

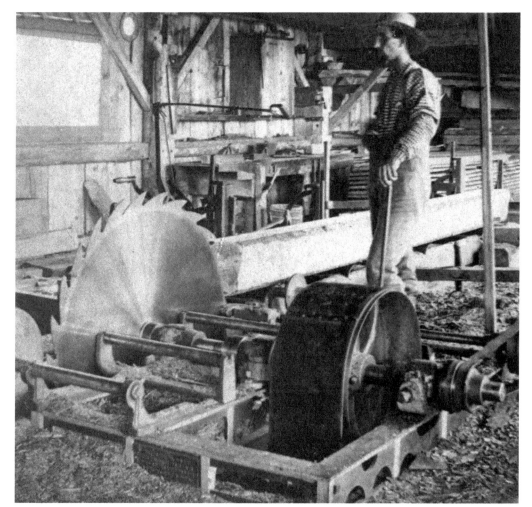

Water-powered sawmills made good business in Vermont throughout the nineteenth century. Logging became Vermont's largest nonagricultural industry by the 1820s, capitalizing on the native timber felled for new settlements. By the 1840s, much of Vermont's timber had been cut, leaving behind a bare countryside. Vermont's sawmills were once again in use by the 1850s—but this time with timber imported from Canada by way of the Richelieu River and Lake Champlain.

Hiram Powers, sculptor of the famed Greek Slave, which was displayed at London's Crystal Palace, was born in 1805 on this Woodstock farm. When Hiram was 13, his family lost their home, suffered crop failure and famine, and headed for Ohio. The experience of the Powers family mirrors a statewide trend, in which native-born sons left the state to find opportunities farther west. Vermonters struggled with population drift throughout the century.

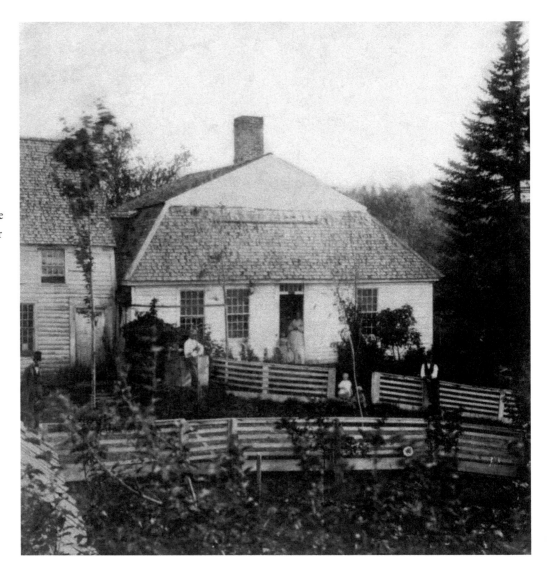

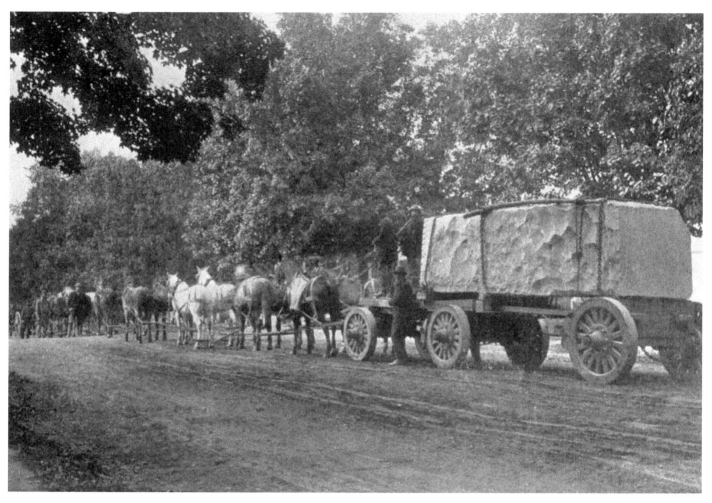

Stonecutters in Barre prepare an enormous block of stone for transport. Before the advent of Vermont railroads, quarries in Massachusetts and Maine had a competitive advantage owing to their access to low-cost coastal water transportation. The granite industry was fraught with dangers for quarrymen, who blasted out and moved these large stones. Silica dust posed the greatest danger. When inhaled by stonecutters, the dust caused lung damage known as "Stonecutters TB."

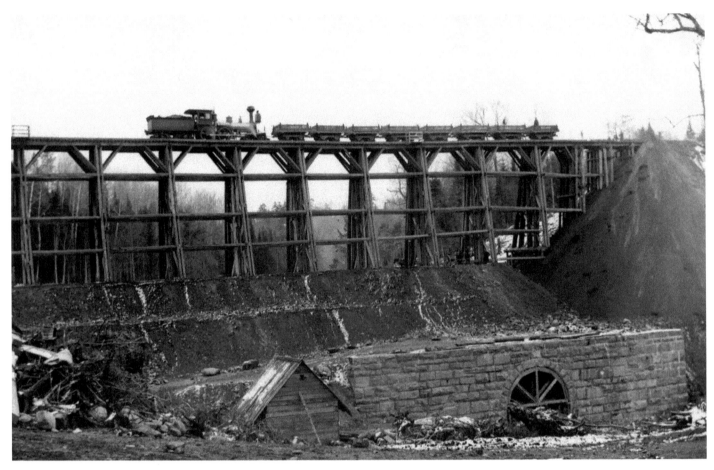

Workers broke ground for Danville's railroad in spring 1870, part of Horace Fairbanks' proposal
for a railroad connecting Portland, Maine, with Ogdensburg, New York—and, eventually, with the
Great Lakes. When the first engine reached Danville in September 1871, the newspaper reported that
Danville was now "the end of the world" and that the town would enjoy "that exalted position during
the whole night," until trackmen resumed extending the line come morning.

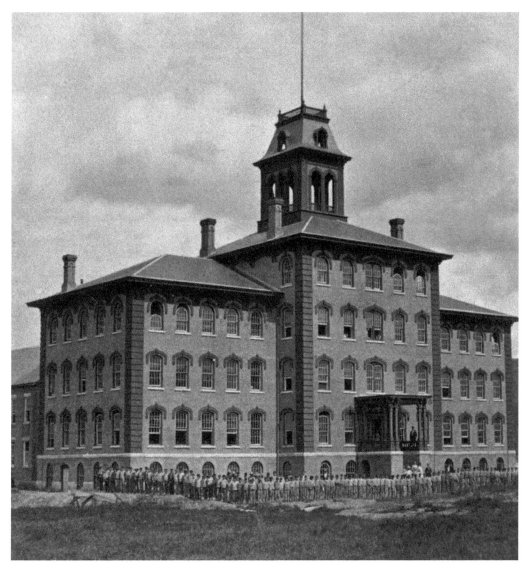

The State Reform School at Waterbury. When a committee selected a site for the state's first reform school, they hoped for a location where "the boys, wherever they are at work on the farm, are never out of sight or hearing." The Reform School in this photograph was built in 1871 at a cost of $50,000. The facility burned just three short years after it opened.

A view of the cascades at Berlin in 1875. This photograph shows the fragility of many Vermont businesses in the late nineteenth century. Now a site for daydreaming, this area below the falls was once home to a gristmill. A fallen beam and discarded millstone in the lower half of the photograph are evidence of the mill.

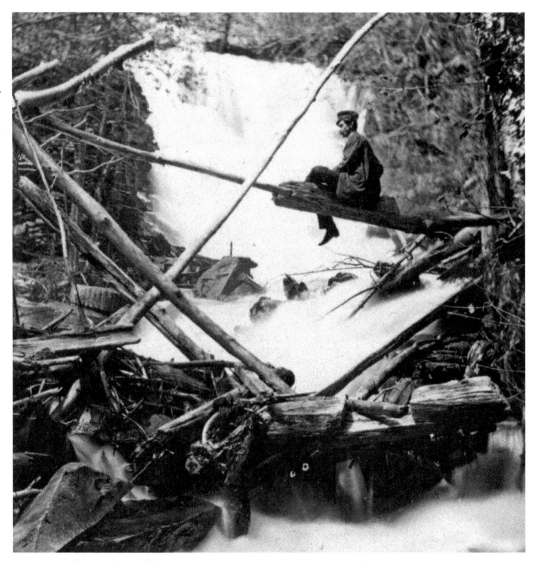

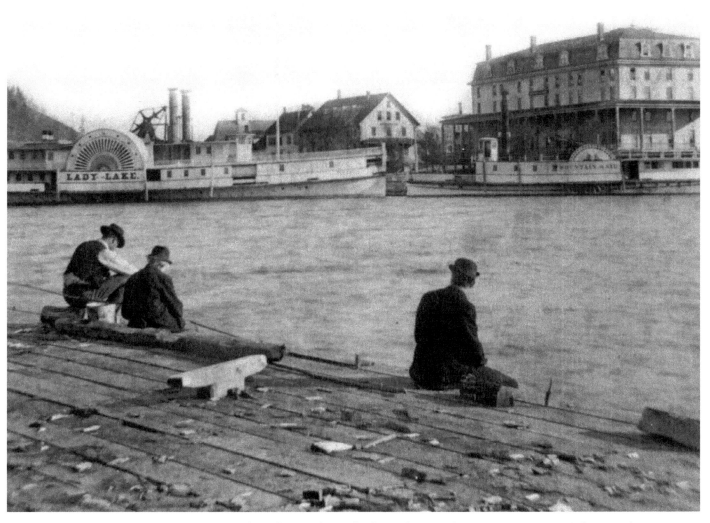

A view from the steamboat wharf on Lake Memphremagog, at Newport. Lake Memphremagog was a travelers' destination in the mid–nineteenth century. This image shows the Memphremagog House, built in 1838. Also visible are the steamboats Lady Lake (left) and Mountain Maid (right). Mountain Maid was the lake's first steamer. Its boiler arrived after a 24-day haul from Montreal.

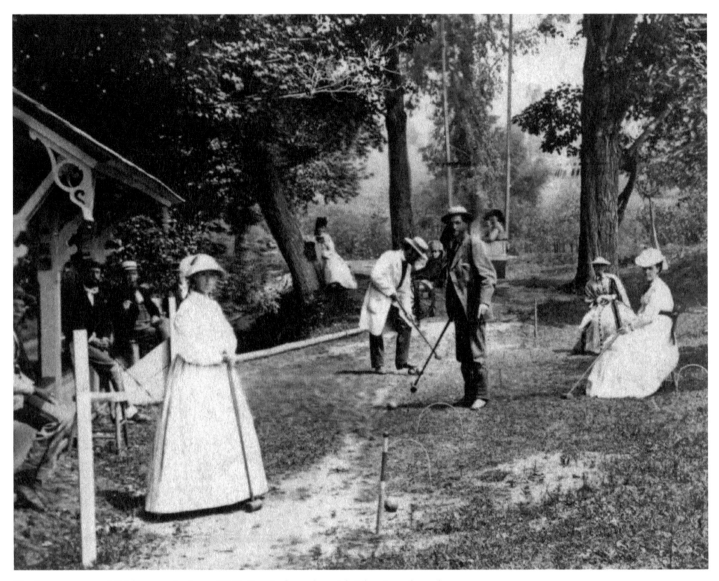

Playing croquet at Middletown Springs, 1875. People from the mid-Atlantic and southern states flocked to Vermont's elevated mountain air to visit spas and springs purporting to offer relief from various ailments. The Middletown Hotel Springs Company numbered its springs according to the illness that each claimed to cure: "No. 1" for piles, "No. 2" for asthma, and a drink from "No. 2 or 3," followed by a drink from "No. 1," for dyspepsia.

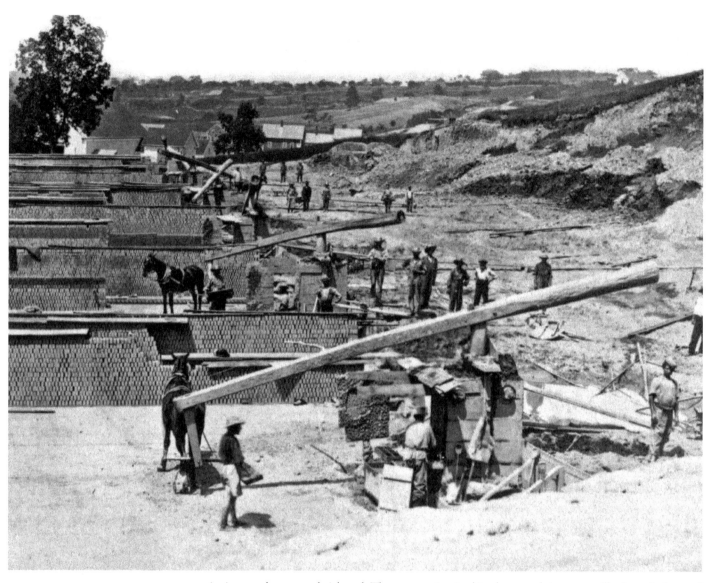

A nineteenth-century brickyard. The contraption in this photograph is a pug mill, also called a mud mill, used to temper newly harvested clay before molding it into bricks. The brick maker added clay and water to the mill and mixed it to achieve an even consistency. Smaller brick operations were less inclined to own pug mills; they did the same work by stomping on the mixture, much like crushing grapes when making wine.

Train wreck near the village of Brockway Mills in Rockingham, 1869. When this locomotive derailed and nearly toppled off the 80-foot bridge, it was the second accident in a decade. Passengers crawled out of the rear cars, which lay precariously at the bridge's edge, fearing their weight would send the wreckage plummeting. In this photograph, spectators make bleachers of the nearby hill to watch the rescue.

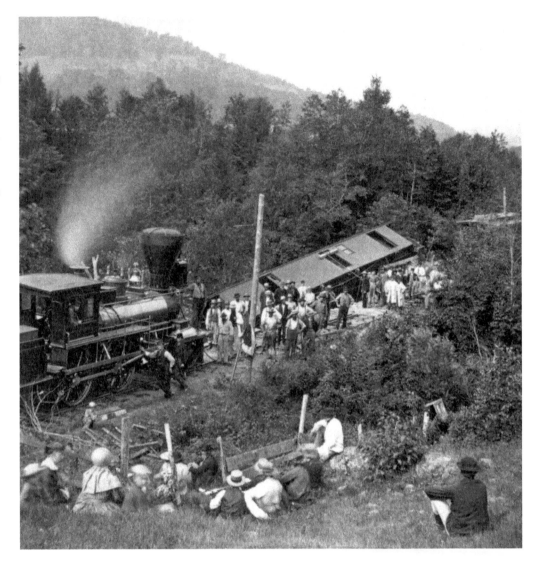

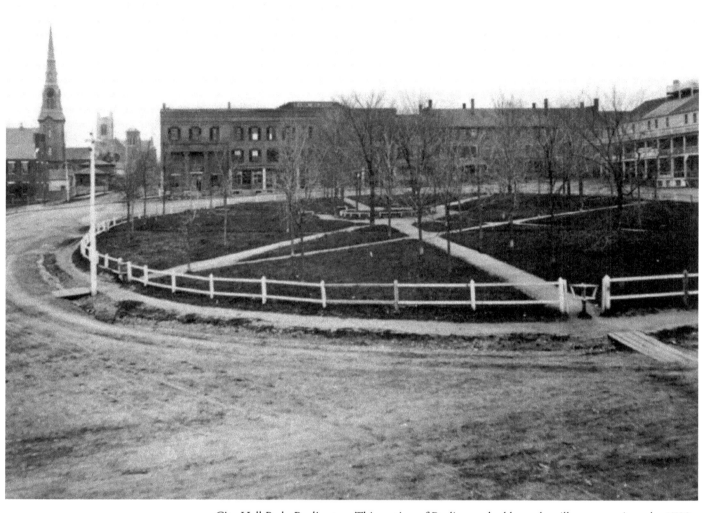

City Hall Park, Burlington. This section of Burlington had been the village green since the 1780s. Known as Courthouse Square, the area quickly became a business center with a bookstore and printer, two tailors, saddlers, a tin shop, attorney's office, and at least three general stores—all before 1810. Like Charlotte, St. Albans, and Vergennes, Burlington served as a commercial hub for Champlain Valley farmers and manufacturers who shipped their goods by steamer or railroad.

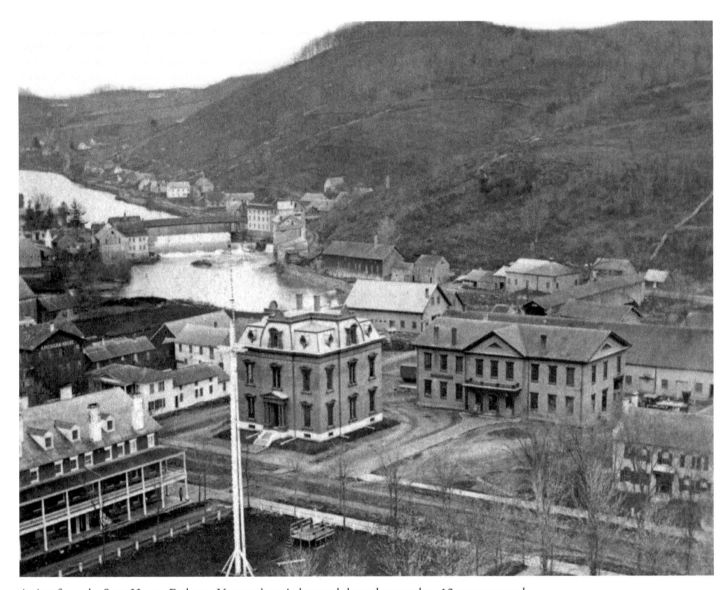

A view from the State House. Early on, Vermont's capital rotated through more than 12 towns around the state. In 1805, the legislature selected Montpelier as the permanent capital—in part as "a measure of peace" to quell competition among upstart towns. With no funds raised as of 1808, Montpelier residents voted a land tax of four cents to pay for the building. They paid two parts of the tax in grain and one part in cash.

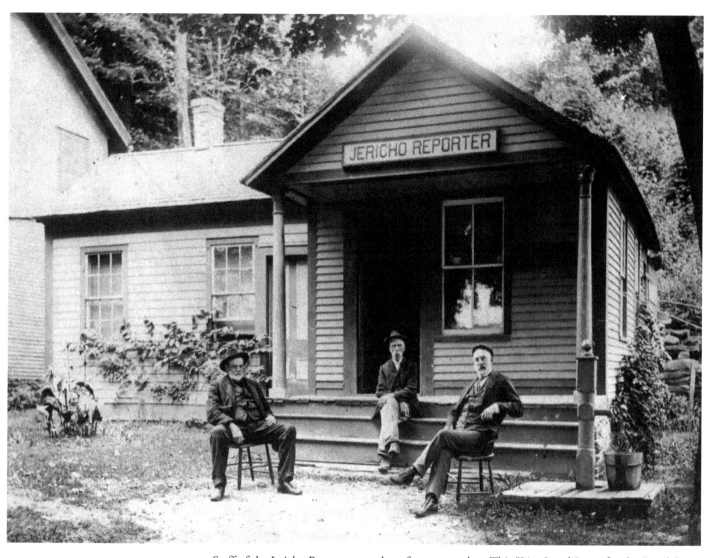

Staff of the Jericho Reporter pose here for a group shot. This "Live Local Paper for the Family" was one of many town newspapers that began publication in the 1880s. The paper pumped news into the local community, from headlines that included "What Colors to Wear" and "How to Cook a Turkey," to notices that "D. E. Rood and his wife are off on Orchard Beach excursion today" and "A. B. Barney has a horse sick with pinkeye."

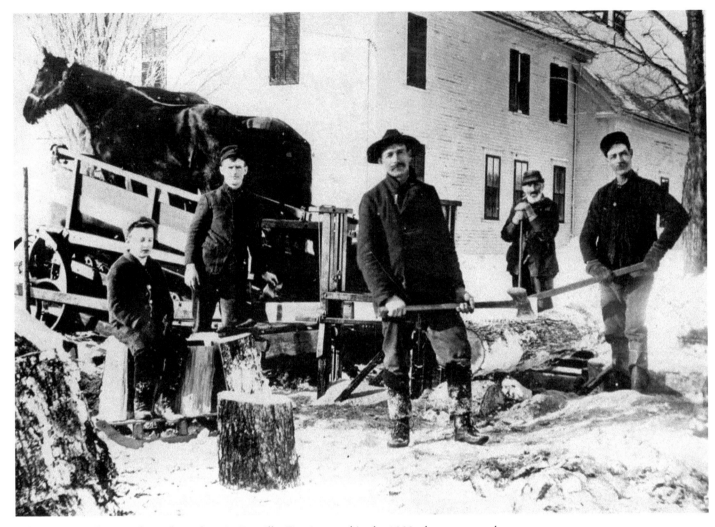

A horse-powered saw at the Webster farm in Danville. First invented in the 1830s, horse-powered treadmills were a great benefit to farmers, who attached these apparatuses to all sorts of tools, including butter churns, grain threshers, water pumps, and other devices. An eyewitness suggested that horses were less enthusiastic about the contraption than farmers were, observing how one horse "pulled right back and tried to lie down" when harnessed to the treads.

This covered bridge in Georgia was one of many in Vermont in the years before 1927. Vermonters built roofs over their bridges to add structural strength and protect them from the elements. In 1927, a massive flood washed away nearly 200 of the state's wooden bridges. Most of them were replaced with concrete-and-steel structures.

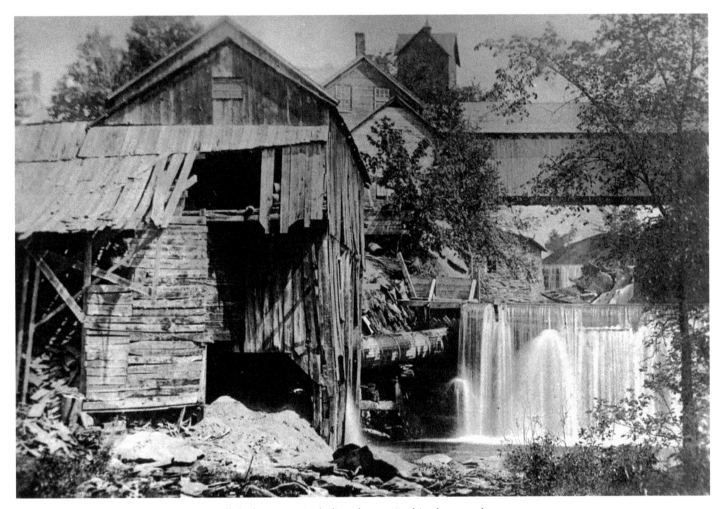

Jericho's Browns River was home to six mills before 1900, including the two in this photograph: the oft-photographed Chittenden Mill, with its cupola in the distance, and Joseph Sinclair's sawmill (foreground), built around 1830. The river was a place for both business and recreation. Referring to this image, a Jericho resident wrote in 1910, "This is the 'old hole' where I used to pull out brook trout big as whales when I was young and imaginative."

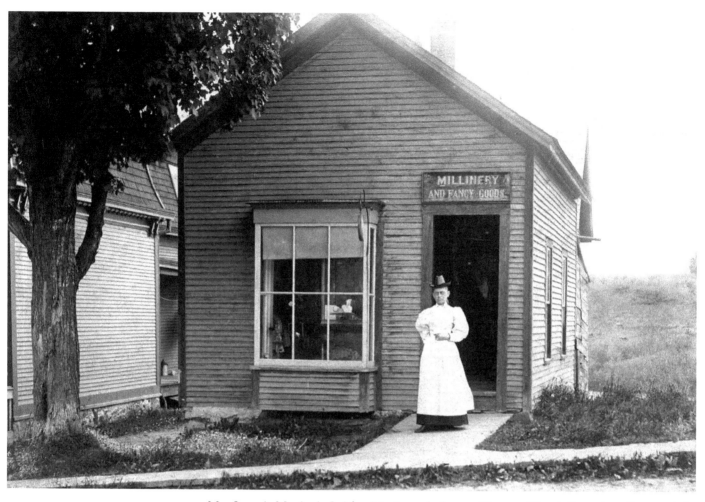

Mrs. Lucy A. Martin, in Jericho. Martin worked as a milliner on Church Street (now Route 15) for more than 30 years. Her husband, Buel, was a jeweler and clock dealer—his round "sign of the watch" hangs from the front of this building. Their house is to the left. Milliners like Lucy received their fine cloth and ribbons from the nation's larger port cities, either by rail or by post.

Hoisting marble in West Rutland. Before 1863, marble quarrying in Vermont was completed largely by hand. A quarryman earned between $1.40 and $2.80 on each of his 10-hour to 12-hour shifts, and he completed a good day's work if he could cut a one-foot by ten-foot channel into the solid marble. Beginning in the 1860s, most quarries converted from hand channeling to reliance on steam power.

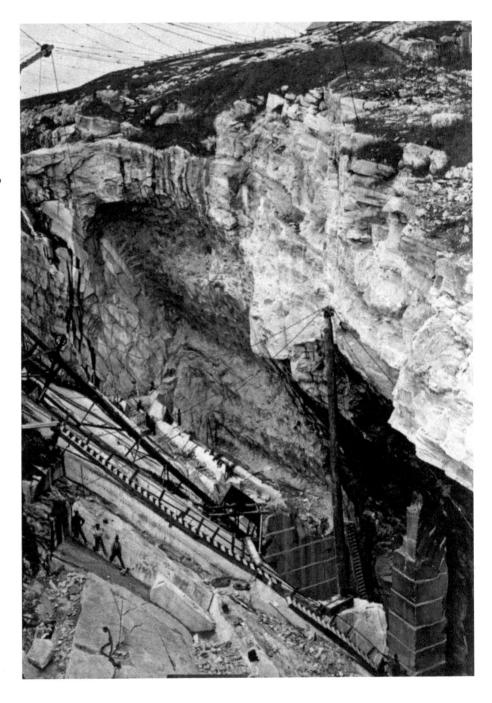

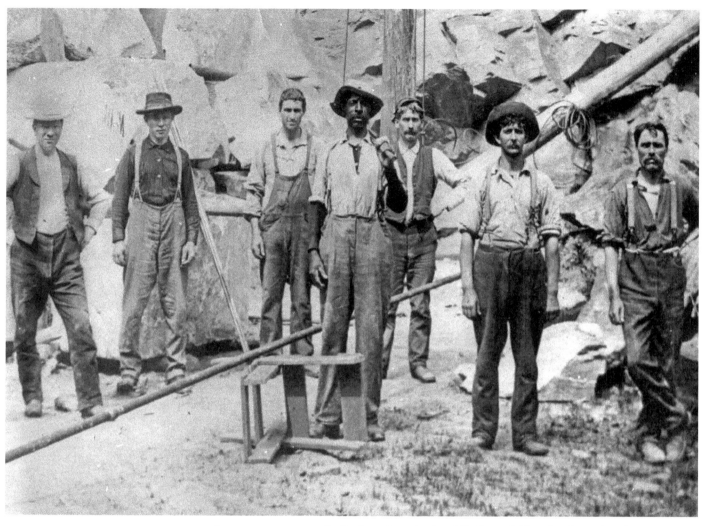

Soapstone quarrymen in Grafton. Opening in 1850, Butterfield & Smith employed 20 men in 13 soapstone quarries atop a hill in Grafton. Soapstone became popular because the slabs cut "like butter" into hearths, stoves, foot warmers, and griddles. Some mills also produced soapstone water pipes, which were posts with a long hole bored through, and sold them for a dollar each. The quarry closed in 1900 when more durable materials rendered soapstone a less attractive resource.

A party at Clarendon Springs in 1885. Vermont boasted more than 100 springs during the nineteenth century, some of which supported health resorts. Clarendon Springs offered diverse opportunities for recreation, including bowling alleys, croquet lawns, and stables. With a large number of clientele hailing from Virginia and the Carolinas, Clarendon's resort business declined after the Civil War. Other Vermont spas would also decline when resorts on the White and Adirondack mountains began to compete.

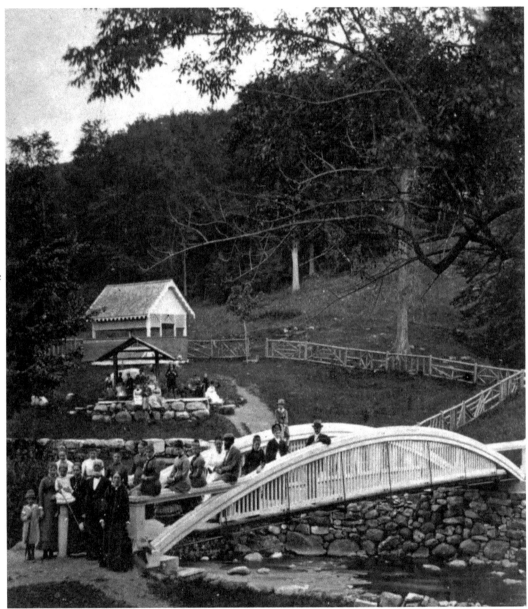

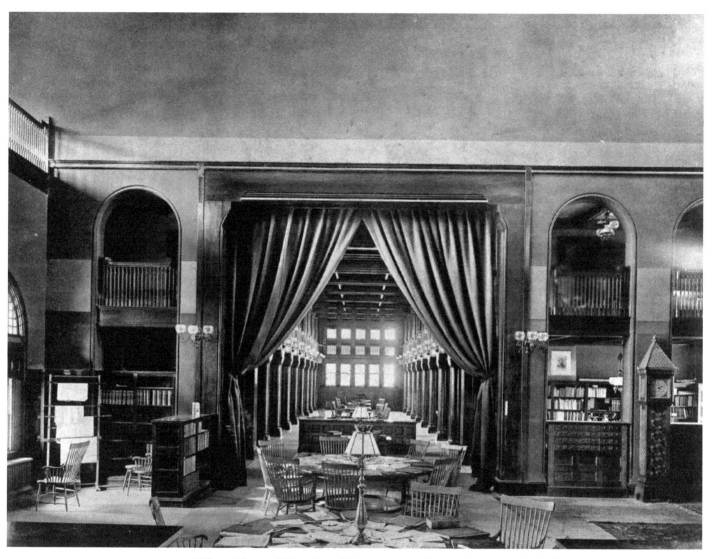

Billings Library, University of Vermont, around 1886. Starting with the few secondhand books of Abel Newell of Colchester in the 1790s, the university library grew to more than 7,000 volumes by the 1830s. The 1860s and 1870s brought significant growth to UVM, and in 1863 the university hired renowned American architect Henry Hobson Richardson to design the Billings Library. Richardson's Romanesque style has been called the first truly American architectural style.

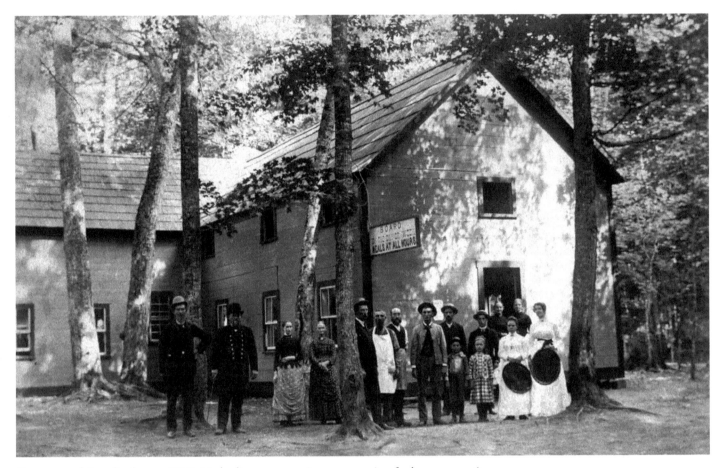

Campground Boardinghouse, 1890. Methodist camp meetings, an occasion for late summertime relaxation with a religious bent, moved to the Morristown area in the 1870s. Situated conveniently on the rail line, the campground seated 2,500 people, and in the 1890s served also as a setting for Republican speechmakers. Towns as far away as Essex and Sheldon built cottages to house visitors, and many pitched tents at the site. The campground closed in August 1902.

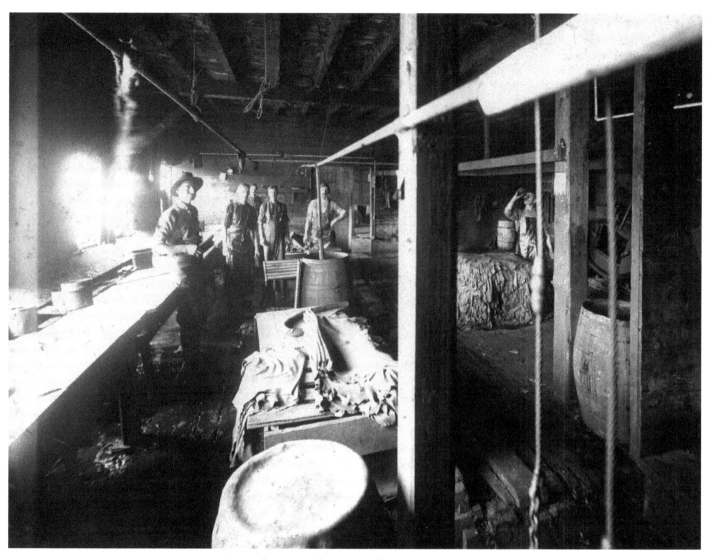

Opened in 1889, the Morrisville Tannery Company became one of the most stable businesses in town. Eventually the company's owners moved the business progressively farther from home—first to Waterbury, then to Massachusetts, and finally to New York. The tannery also saw the nature of its business change, first specializing in horse harnesses and then shifting to belt leather as horse travel became less popular.

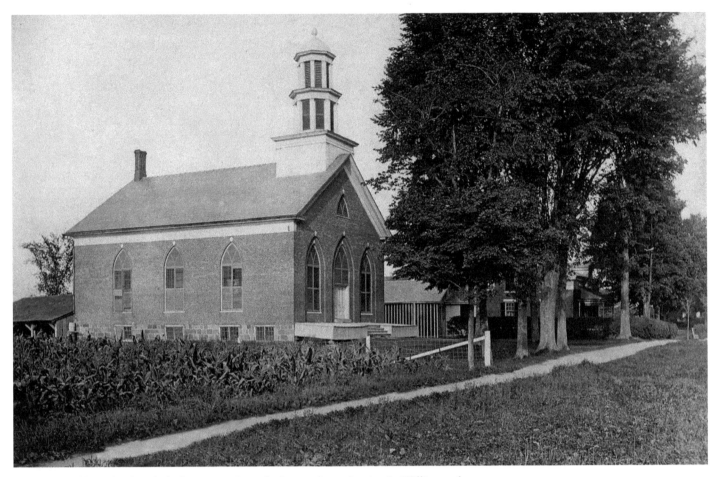

Williston's Old Brick Church, before 1900. Once the largest denomination in Williston, the Congregationalists built the Old Brick Church in 1832. Slowly, the congregation dwindled as splinter groups left to form their own denominations. Universalists built their own meeting place in 1860, and in 1869 the Methodists constructed a separate house. In 1899, the Congregationalists themselves left the Old Brick Church and merged with the Methodists down the road. The building remained largely vacant until the 1960s. It stands today as one of the town's landmark structures.

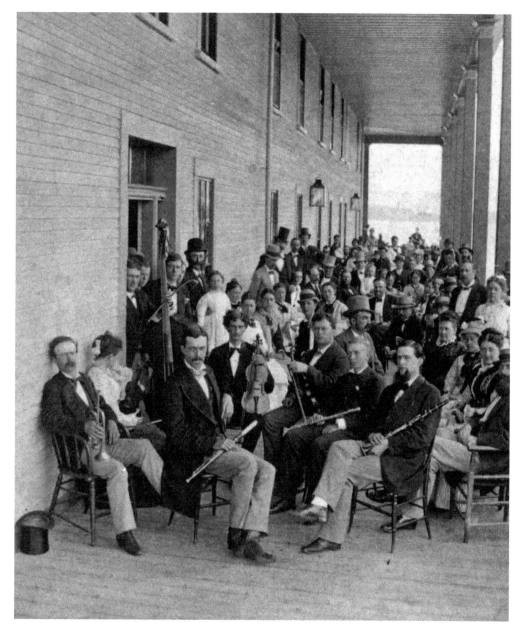

A balcony group plays at the Memphremagog House in Newport. The late nineteenth century brought an explosion of social and entertainment options to Vermonters, including professional associations, recreation clubs, and musical groups and gatherings. These activities and organizations helped to bolster community ties at a time when many towns were tackling the challenges of dwindling population.

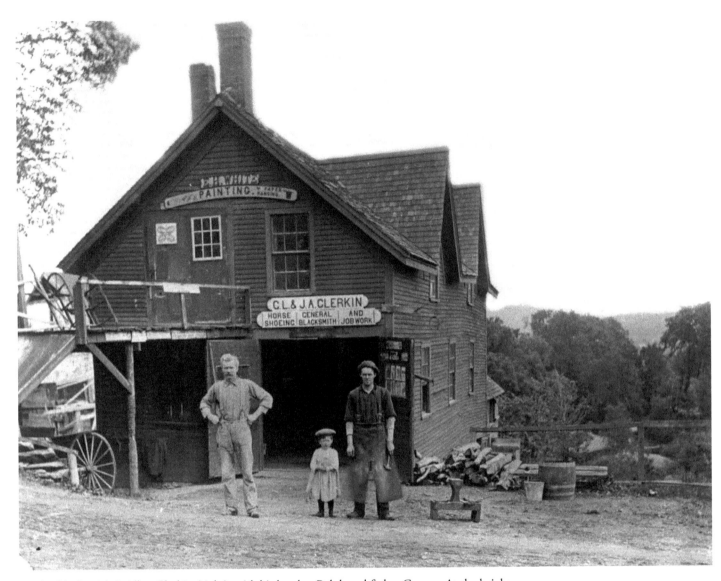

Jericho blacksmith J. Allan Clerkin (right), with his brother Ralph and father George. At the height of horse-and-buggy travel, blacksmiths enjoyed a robust trade shoeing horses and fabricating wagon wheels for the community. At least five of these artisans plied their trade in turn-of-the-century Jericho. When automobiles arrived some years later, a concrete bridge replaced the wooden one next to this shop and the resident blacksmith converted half his business into a service station.

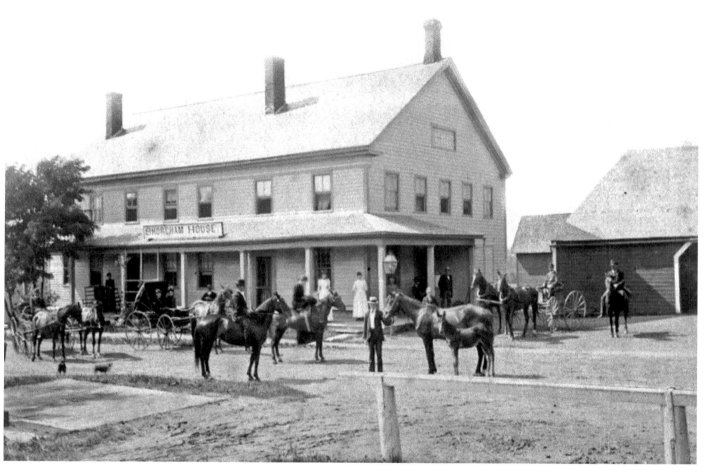

In the late nineteenth century, inns like the Shoreham House hosted travelers leaving Vermont for better situations. Novelist Nathaniel Hawthorne marveled at how this exodus made international junctions of Lake Champlain's port towns, describing the "continual succession of travelers who spent an idle quarter of an hour in waiting for the ferryboat, affording me just enough time to . . . penetrate their mysteries and be rid of them without the risk of tediousness on either side."

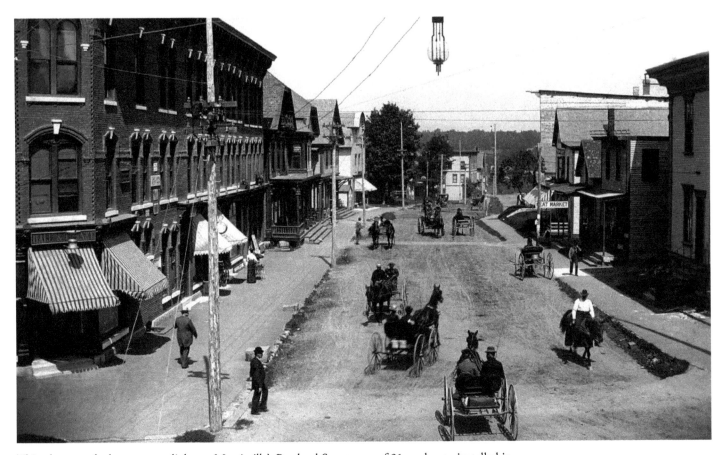

This photograph shows a streetlight on Morrisville's Portland Street, one of 21 arc lamps installed in 1895. The Lamoille River powered Morrisville's first electric plant, built in 1894. The plant manager started the plant at dusk and left it running until morning. If there was not enough water to power the lights through the night, the town's early risers woke up in the dark.

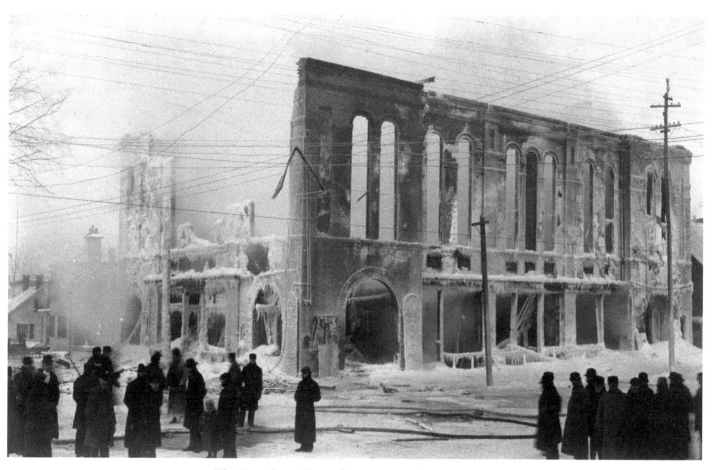

The Barre Opera House fire, 1898. Barre's Opera House attracted music, lectures, and theater that was heard the world around. When the theater caught fire one January night, firemen discovered that the two nearest hydrants had frozen. The roof soon collapsed in flames and the handsome edifice was gutted. In the following morning's paper, photographer H. E. Cutter announced that he would sell photographs of the fire for 25¢ apiece.

The Tucker Toll Bridge, shown here around the turn of the century. Nathaniel Tucker originally bought a toll bridge at Bellows Falls in 1826. It was the first bridge to cross the Connecticut River, and Tucker collected the tolls himself. One day he was surprised to look upriver and see another bridge about to crash over the falls. The intruder was the Cheshire Bridge, which had broken free and, fortunately for Tucker, happened to shatter before it hit his bridge. Within a year, Tucker chose to rebuild his bridge with this larger and higher structure, which endured through the remainder of the century.

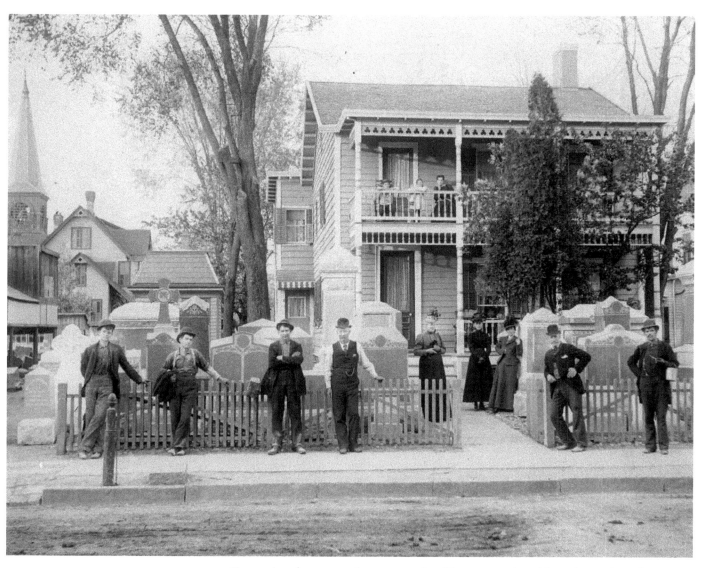

Vermont's early grave markers were made of limestone and marble, and sometimes slate or cast metal. Granite became the stone of choice in the 1880s because it resisted staining and erosion, and because it polished to a fine luster. Stone artisans from Italy and Scotland—along with Scandinavians, Spaniards, Lebanese, Greeks, and French Canadians— practiced their trade in Barre beginning in the 1880s.

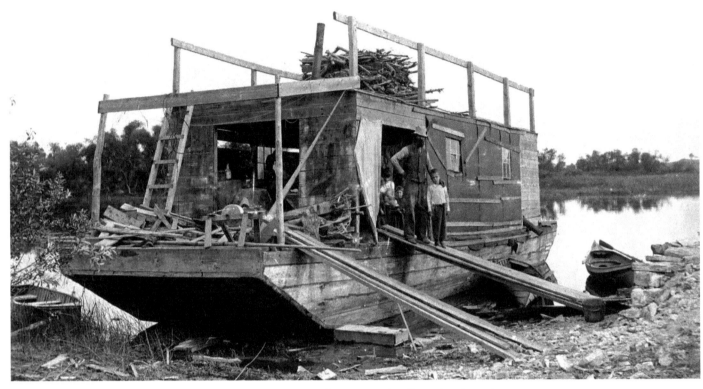

Thurlow Ploof and family on the Otter Creek, 1893. Nineteenth-century Lake Champlain hosted a vibrant maritime community of people living on the lake. They included "canalers," Vermonters who lived on boats that were towed through the waterways between New York and Canada, and families like the Ploofs, who served as day laborers in the lake's port communities. These laborers lived on their boats and squatted on nearby land when they needed to come ashore.

The 1881 Randolph Railroad station. In addition to hauling daily freight and passengers, the railroads promoted cultural activities. When Dubois and Gay's Hall hosted the Randolph Musical Association in 1899, the Central Vermont Railroad reduced its rates to help passengers attend the big day.

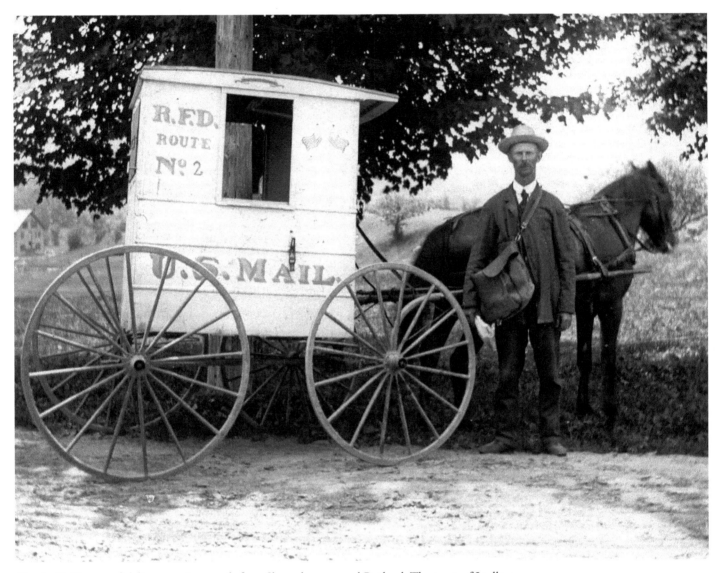

Charles E. Pitts, rural delivery carrier, travels from Shrewsbury toward Rutland. The town of Ludlow participated in a national rural free delivery experiment in 1891, and Grand Isle received RFD service in 1896. By 1904, there were 212 rural routes in Vermont, and the U.S. postmaster general declared that RFD appeared "to give great satisfaction to the community served." Rutland was the sixth town in the state to host the service.

Two Worlds Collide

(1900–1926)

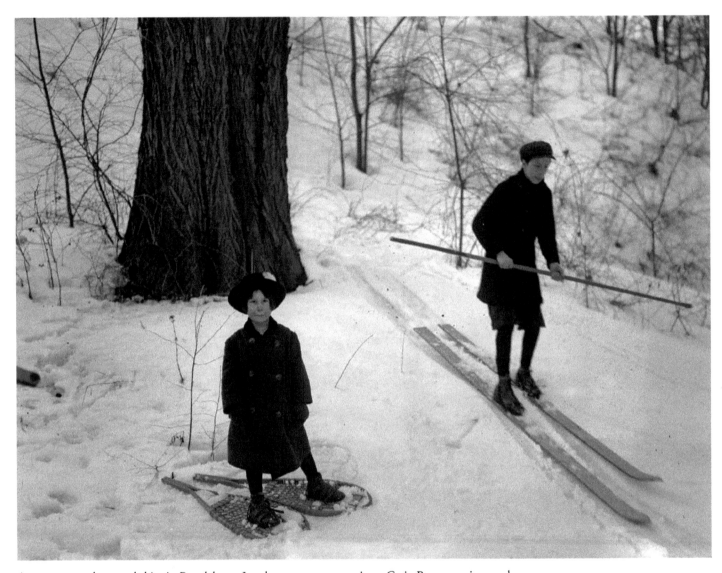

A young snowshoer and skier in Brattleboro. Lumber company proprietor Craig Burt experimented with handmade skis early in the twentieth century by soaking hardwood boards in hot sawdust and then turning up the front ends. While snowshoeing remained Vermonters' favorite sport through the 1920s, Burt advocated skiing since it would be "as good-business as any summer development we have, and much better than some."

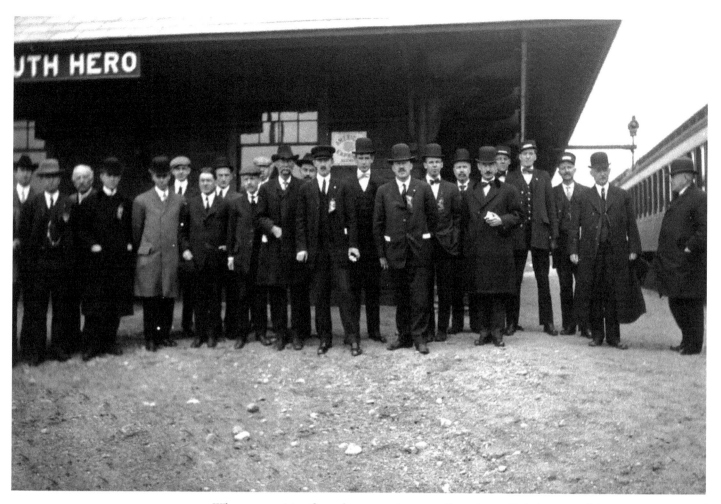

When competition from the country's western farms intensified, the state of Vermont experimented with a number of programs to help struggling local farmers. These included the Better Farming Special, a traveling railroad exhibit that traversed the state displaying modern machinery and horticultural methods. Farmers appreciated the assistance, but were skeptical of state involvement in agricultural programs, concerned that it might frustrate hands-on decision-making by those closest to the land.

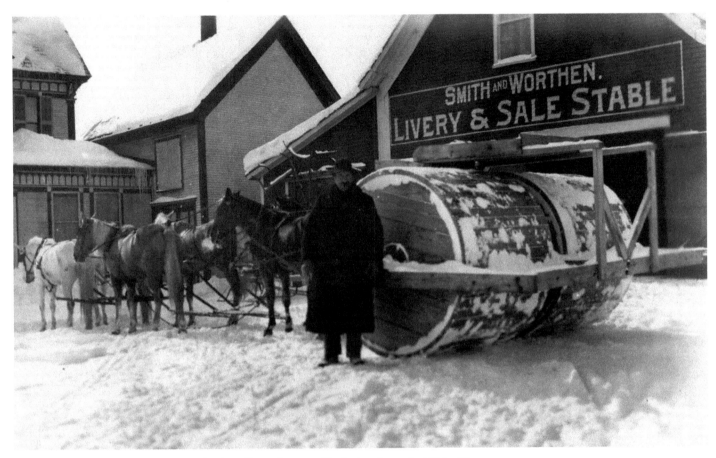

Andrew Smith drove this snow roller for the village of Morrisville during the early 1900s. He was an obvious choice for the job, since he owned the livery stable pictured in this photograph. During the winter months, Vermonters found compressing the snow easier than plowing it, for at least one practical reason—many residents used horse-drawn sleighs instead of wagons during the snowy season.

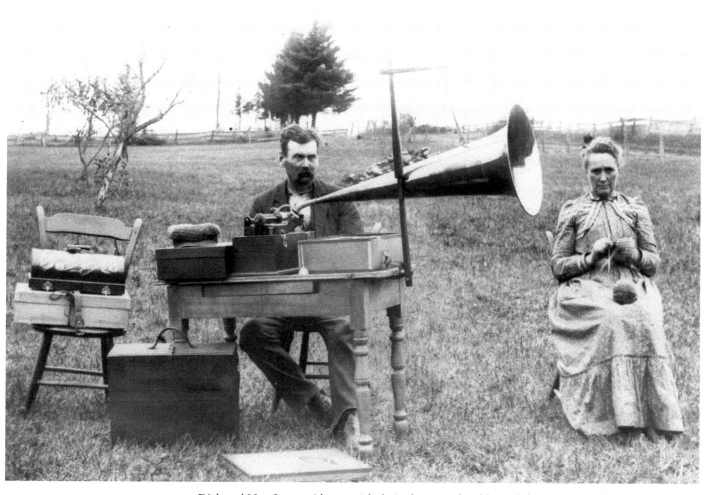

Dick and Nett Langmaid pose with their phonograph, table, and chairs near their home around West Danville in 1900. Traveling photographers of the day offered residents the opportunity to record themselves and their most-prized belongings— furniture, livestock, and the family home—for relatives afar. No doubt the Langmaids particularly cherished their phonograph. Invented by Thomas Edison in 1877, these instruments were just becoming affordable at the turn of the century.

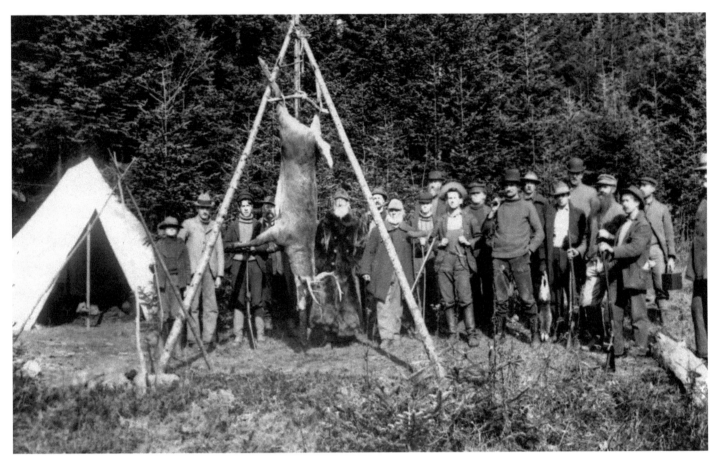

A deer camp in northeast Vermont. Hunting deer in Vermont was prohibited from 1865 to 1897, the result of over-hunting during the early nineteenth century. The state reintroduced the animals by importing 17 deer from New York in the late 1870s. In the 1890s, the state broadened the jurisdiction of the Fish Commission to include game and reopened the sport. Hunting licenses were required of out-ofstaters at first, and then of in-state residents as well.

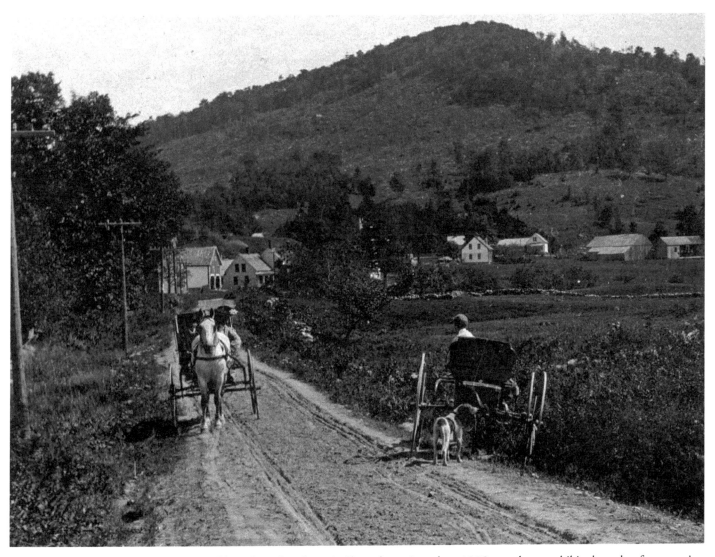

Yielding the right-of-way in Shrewsbury. As early as 1805, state laws prohibited coaches from turning off the road "with an intent to evade the toll," and by 1900, with 14,825 miles of road in Vermont, more regulation was clearly needed. In 1933, the state took full control of the highways. Vermont roads were also notoriously sloppy, which led to the Vermont League for Good Roads, organized by citizens in the 1890s.

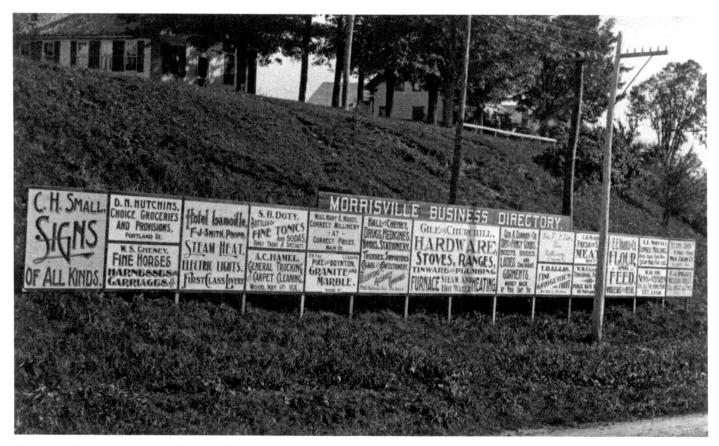

Around 1900, this hand-lettered business directory below East High Street greeted travelers from Stowe as they entered Morrisville. In 1937, the town of Springfield became the first to introduce highway billboards. The signs created consternation among some. Well-known writer, publicist, and founder of Weston's Vermont Country Store, Vrest Orton once called billboards "un-Vermonterish." In 1967, the state banned billboards altogether—but only after a fight with lobbyists, who argued for their benefit to tourists.

The Rutland Railroad quickly laid track from Rutland to the Burlington area, but like many of Vermont's railroad ventures, the company struggled to complete its route as far as the state's border. In 1907, the Rutland employed no fewer than 35 engineers, 13 conductors, 40 clerks, and 12 firemen to stoke the trains' fires. Railroad companies and their allied industries provided employment for many people in depot towns.

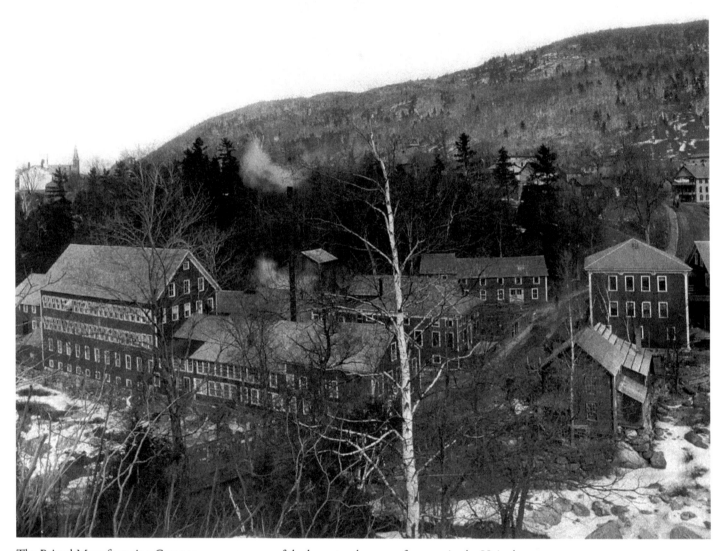

The Bristol Manufacturing Company was once one of the largest casket manufacturers in the United States. The company's lavish catalog boasted highly crafted designs using pleated silk linings, selections of hardwoods, and elaborate construction methods—quite a change from the simple pine boxes that preceded the Civil War. The company profited alongside a bustling national funeral industry, which benefited from a Victorian-era taste for the ornate.

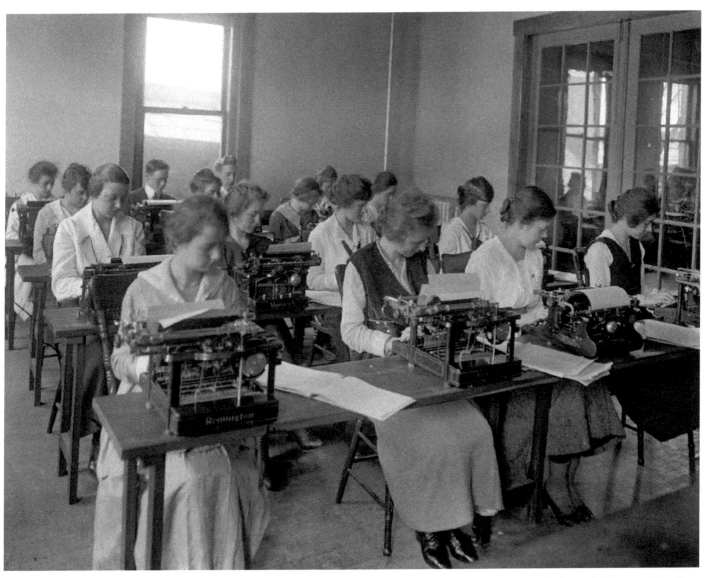

Clawson-Hamilton Commercial College, Brattleboro. Around 1908, Neil Clawson's Clawson-Hamilton College supplied "experienced or inexperienced" bookkeepers, clerks, and stenographers at no charge to nearby businesses in Brattleboro. The school also bought, sold, rented, and repaired typewriters. In 1918, Clawson-Hamilton joined the Bay Path Institute of Springfield, Massachusetts, and renamed itself the Brattleboro Business Institute.

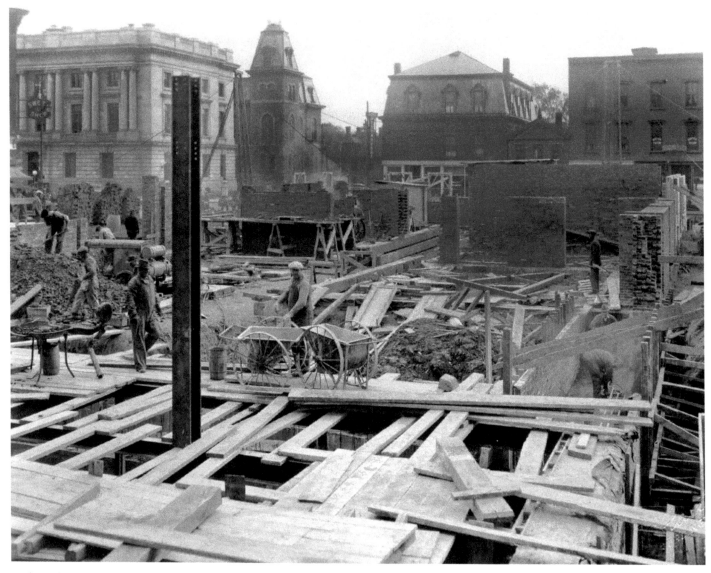

Built in classical revival style, Burlington's City Hall featured marble from Proctor, granite from Barre, slate from West Pawlet, and bricks from Essex Junction. City residents paid out nearly $500,000 to complete the new structure—including more than $23,000 to McKim, Mead, and White, a premier New York architecture firm of the era. The 1926 project, one of many large-scale Burlington construction projects in the 1920s, earned Mayor Clarence Beecher the nickname "Beecher the Builder."

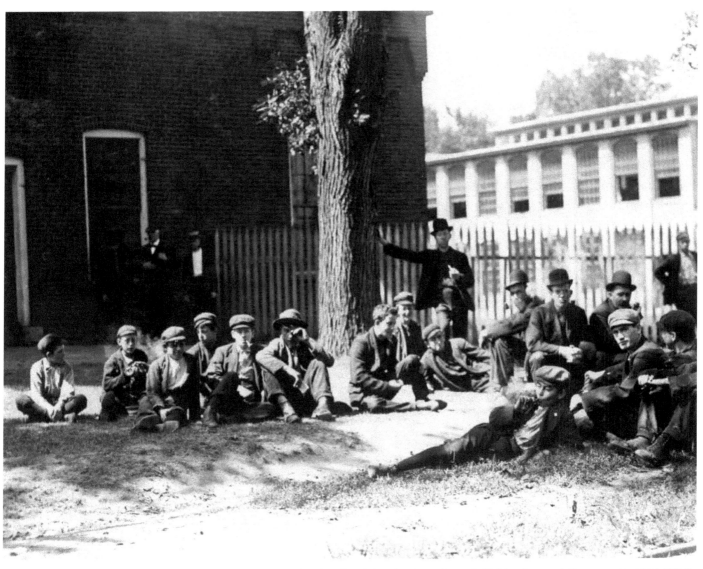

Youngsters take their lunch break at Bennington's Holden-Leonard Company in 1910. While Vermont's rural areas struggled with population losses through much of the nineteenth century, the state's 12 largest towns grew in population. In addition to immigration from places like Canada, Ireland, Sweden, and Italy, much of this population increase resulted from the influx of young people moving from their parents' farms to work in the mills and factories of the industrial towns.

Two "pin boys" and associates at the Bowling Academy in Burlington around 1910. Although bowling became much more mainstream after World War II, in its early years the game was associated with immigrants and saloons, places that most women avoided. Burlington's 1910 city directory lists one bowling establishment: Herbert Pitcher's restaurant and arcade at 165 Main Street.

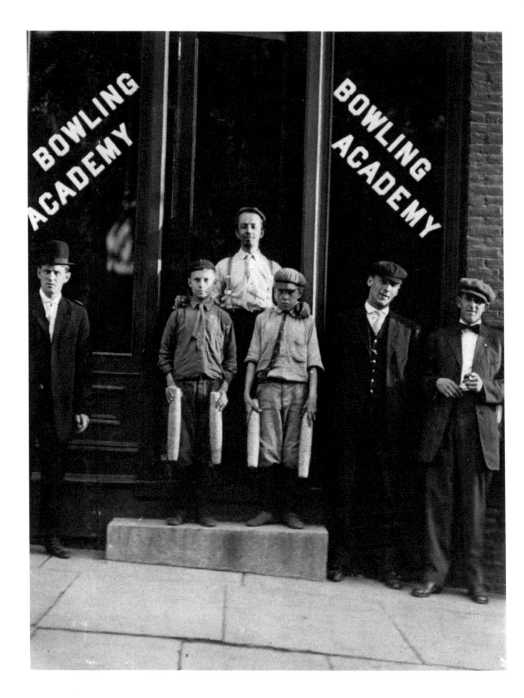

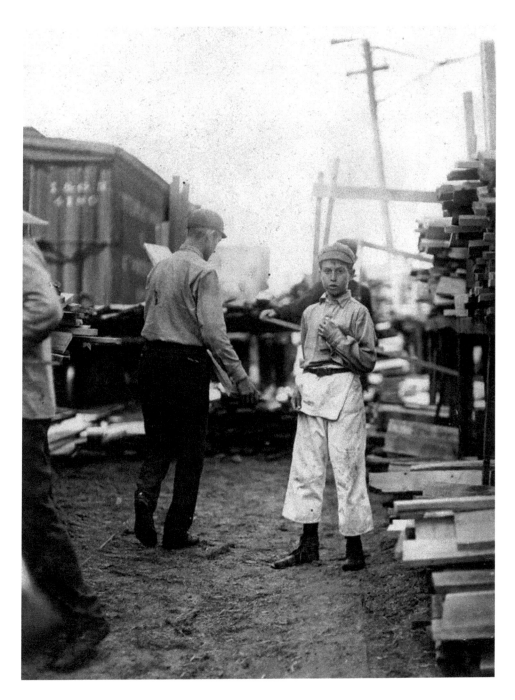

A young worker at Burlington's Hickok Lumber Company, around 1910. Horatio Hickok's Pine Street manufacturing company sold lumber, packaging boxes, cloth boards, and shooks. Hickok contracted with lumber harvesters in Underhill, and like many nineteenth-century manufacturers, employed young people who had come from the rural areas seeking work. Lewis Hine, who took many photographs on behalf of the National Child Labor Committee's efforts to eliminate child labor, took this photograph.

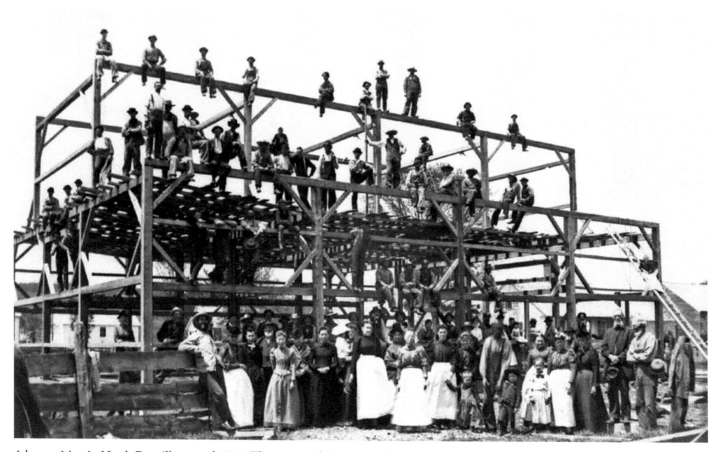

A barn raising in North Danville around 1910. The success of the nineteenth-century lumber industry left few large trees to furnish long timbers for barns such as this one. Farmers often harvested the trees for their barns from their own property. Balloon or plank framing became more common in the twentieth century, in part because it required less lumber and labor than post-and-beam timber-framing, shown here.

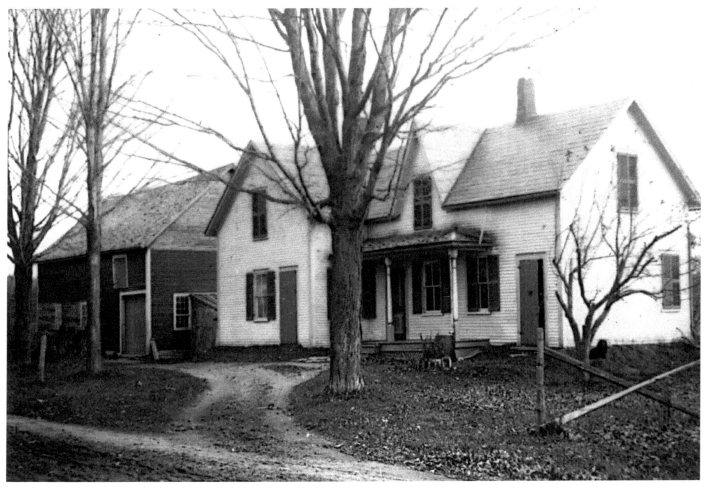

A farmhouse on Lee River Road in Jericho. A popular form of New England architecture, the "big house, little house, back house, barn" was a nineteenth-century design. The string of connected buildings progressed from a formal parlor (big house) to a kitchen (little house), storage area (back house), and animal shelter (barn). Some suggest that the layout protected farmers from weather, but the arrangement may simply represent an efficient use of workspace.

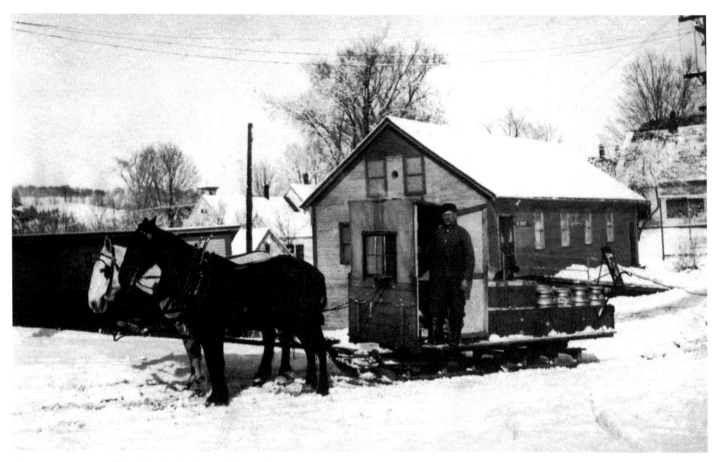

A man transports milk in Jericho by horse-drawn sleigh, complete with an enclosed cab and windshield to keep out the sharp winter air. New modes of transportation greatly affected dairy farmers in Vermont. Refrigerated railcars allowed Vermont cheese, butter, and especially milk to travel to more distant markets like Boston. By the early twentieth century, most farms located near railroad hubs had significantly increased the size of their herds to capitalize on rail transport.

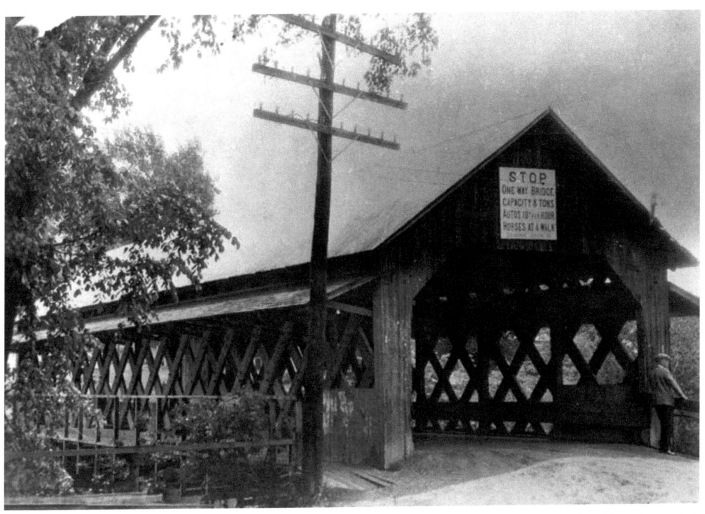

Covered bridge at Jericho. This bridge suggests the many transportation modes of the early twentieth century, including automobiles, horses, and walking. Jericho resident Earl Cross recalled that children used the road for sledding: he and his friends would zip toward the bridge, hoping to make the sharp turn just before the entrance. When Cross missed his turn one year, he crashed into the old Home Market—much to the surprise of the clerk inside.

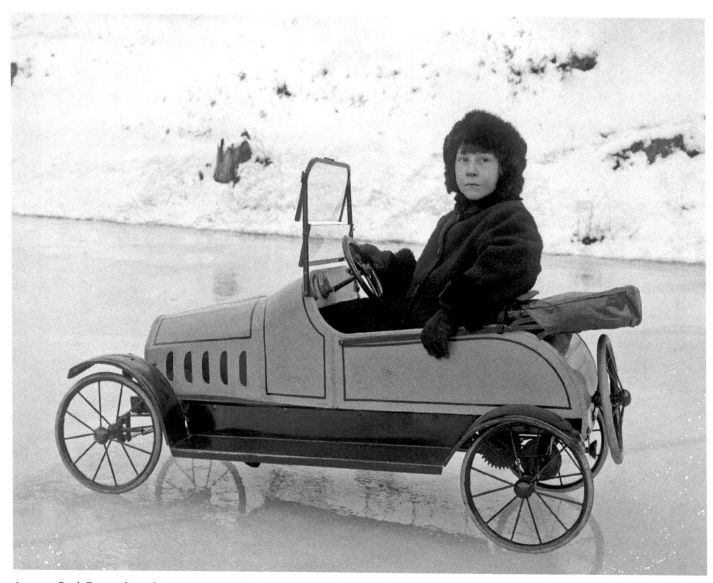

A young Paul Crown drives his toy car across the ice. Crown was the son of Brattleboro-based photographer Benjamin Crown and his wife, Clara. By the time Paul was ten, his three older brothers—Harold, Raymond, and Richard—all worked while still living at home. Raymond worked in a toyshop and may have provided this mechanized car—complete with gears and a spare tire.

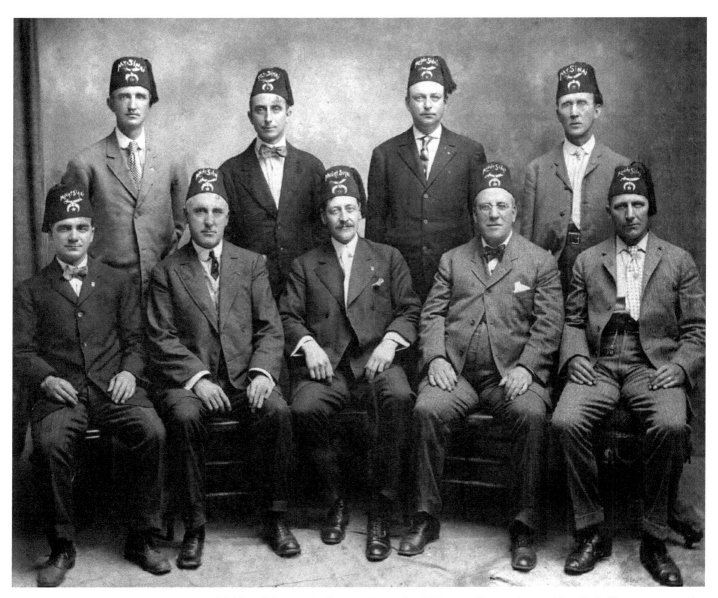

Nobles of the Mystic Shrine, Mount Sinai Chapter. Conjured up in New York City as a new outlet for the Masons' fraternity, the "Shriners" stressed fun and fellowship by combining socializing, philanthropy, and the romantic exoticism of foreign lands. In 1876, Montpelier (Mount Sinai) followed New York City (Mecca) and Rochester (Damascus) as the third temple in the organization.

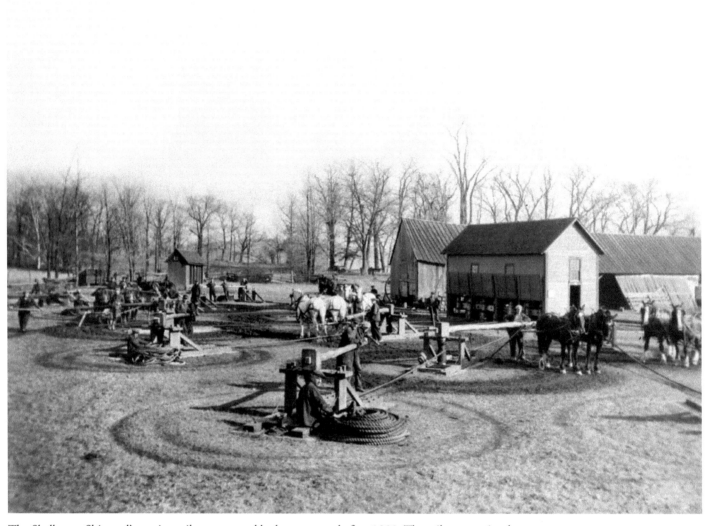

The Shelburne Shipyard's marine railway operated by horse power before 1929. The railway consisted of two tracks that stretched into the water at Shelburne Bay. Boats steered onto a cradle riding on rails and were hoisted out of the water by 14 horses. Vessels as large as Vermont III and Ticonderoga, both sidewheel steamers more than 200 feet long, were pulled aground with this horse-driven mechanism.

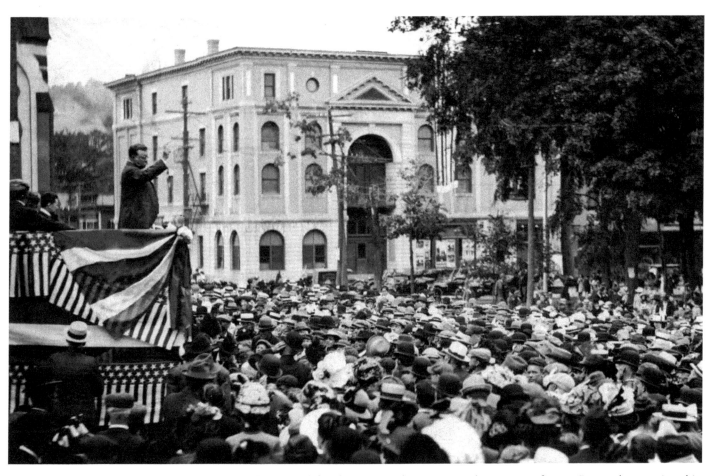

Presidential nominee Theodore Roosevelt in Barre. In the summer of 1912, Roosevelt campaigned in Vermont, with stops that included Barre and the Lamoille County Fair. (The fair stayed open one extra day to host the Progressive Party icon.) Roosevelt, who organized the Progressive Party after an ideological split with the Republicans' Taft, faced a tough challenge with Vermonters, who tended to vote Republican in state elections. Nationwide, Roosevelt's bid for a third term in office succeeded against Taft, but split the electorate, swinging the election to the Democratic nominee, Woodrow Wilson.

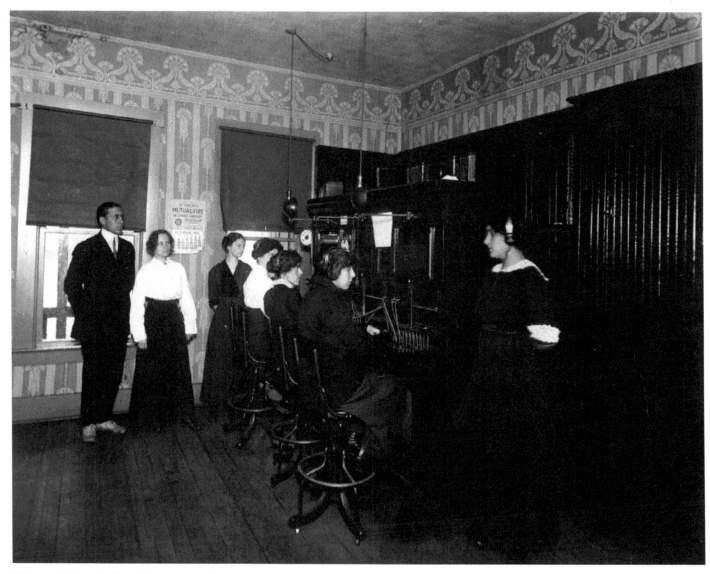

The state's first telephone line was installed in St. Johnsbury in 1877 when a druggist ran a line from his store to his home. By 1882, the Bell Telephone Exchange had come to Lamoille County, connecting eight businesses in Hyde Park and Morrisville, as well as the banks and railroad depots of the two towns. This 1913 photograph shows New England Telephone and Telegraph Company's switchboard crew in Morrisville, with chief operator Juliaett Brooks standing at right.

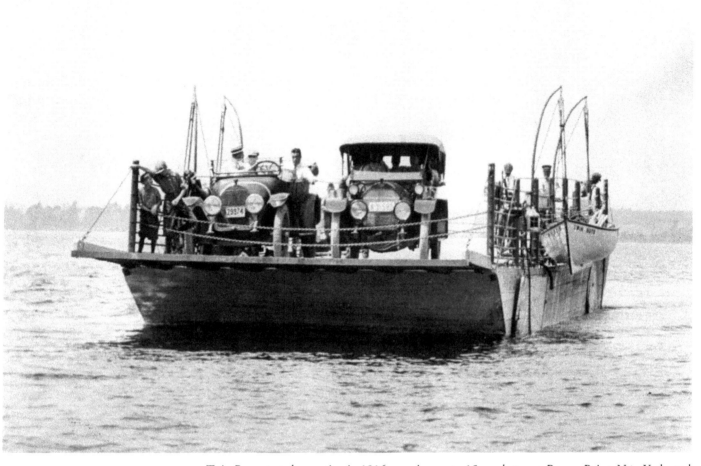

Twin Boys started operating in 1916, carrying up to 15 cars between Rouses Point, New York, and Alburgh. The gasoline-powered ferry was named by reference to the sons of the owner, William Sweet. Travelers recalled their early trips on Lake Champlain's numerous small automobile ferries as a worrisome experience—alluding to the deckhands, who carefully assessed the weight of vehicles and the ferry's available space. The frequency of strong winds on the lake also ensured passengers an exciting ride.

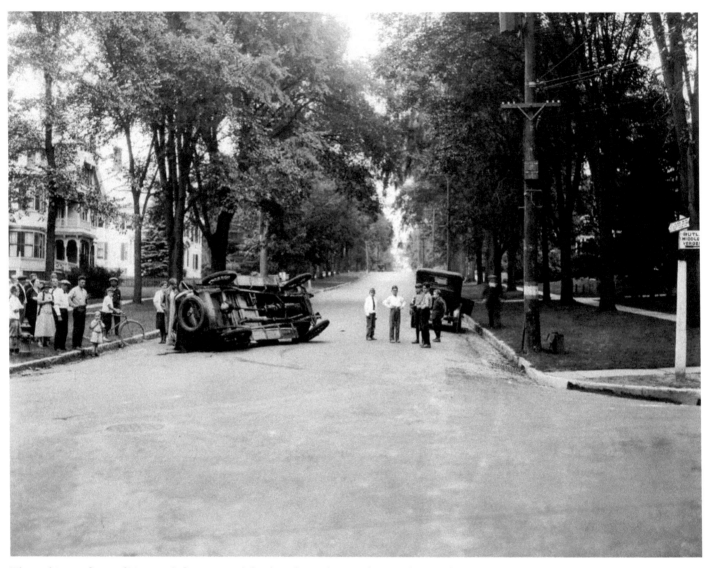

The architect of one of Vermont's first automobiles, bicycle mechanic John J. Williams of Montpelier, told his son that a car was "easier to handle than a bicycle. You don't have to balance it." Williams, who later owned a car dealership, often assigned his son the task of teaching customers how to drive their first vehicle—a process he called "breaking them in." Driving automobiles didn't come easy to all Vermonters—this accident in Burlington has attracted quite a bit of attention.

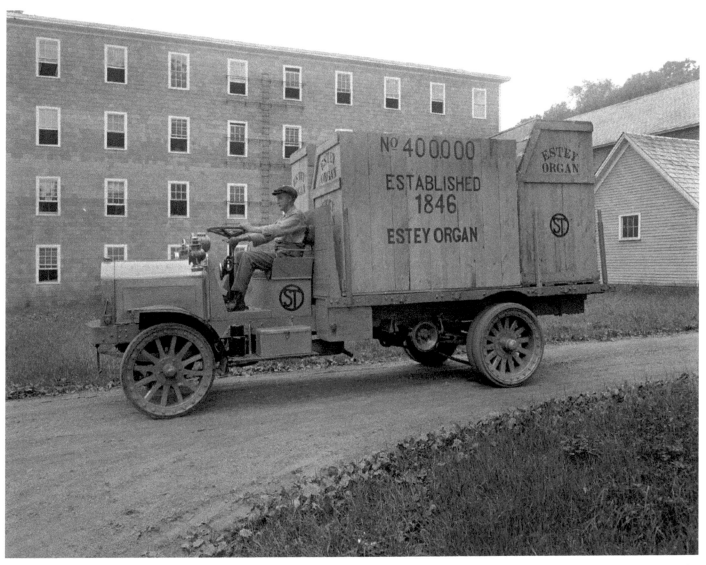

Plumber Jacob Estey built a highly successful organ business in Brattleboro. More affordable than the piano and easier to keep tuned, the reed organ became the quintessential Victorian-era instrument in American homes. Brattleboro hosted a long list of music stores and instrument makers, including one whose organ was deemed, dubiously, "better adapted to accompany the scraping hum of a wood sawyer."

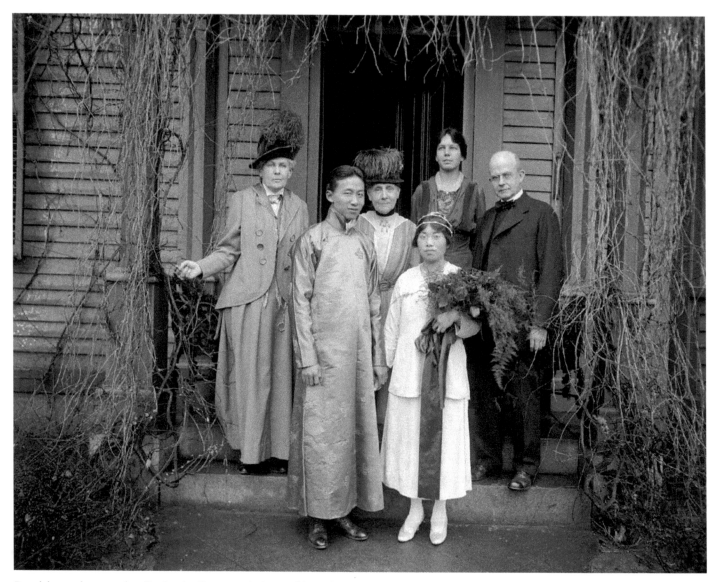

Brattleboro photographer Benjamin Crown took this wedding photograph of Yangma Kno and Mai Tsu in 1918. Census takers recorded fewer Asian immigrants living in Vermont during these years: the number dropped from 42 persons in 1900 to just 10 in 1920. The 1920 census lists three Asian immigrants living in Brattleboro: Edward Uchida, a golf club manager; F. Moy Fing, who ran a laundry; and Masser Itagaki, private chef for organ company president Jacob Gray Estey.

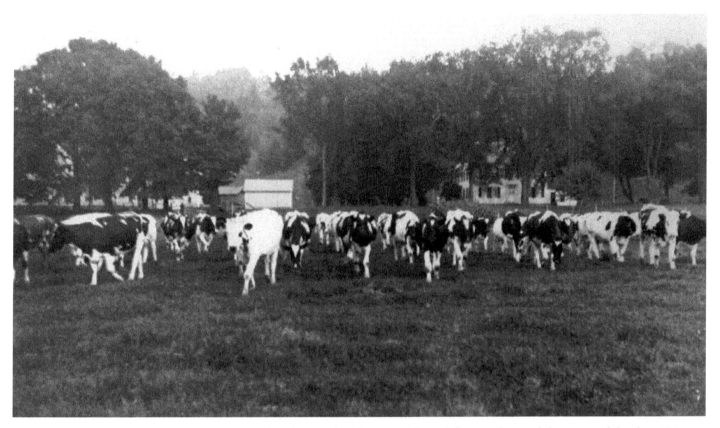

Vermont's early agricultural economy focused first on wheat and then on wool, but by 1900 most Vermont farmers had turned to dairy production. They also diversified their products to protect themselves from competition from western states. Wilson A. Bentley, Jericho's "Snowflake Man," famous for his thousands of photographs of snow crystals, recorded this image in the pasture next to his home.

Built in 1893, Fort Ethan Allen boosted the cultural offerings of the region. The parade grounds hosted townspeople for baseball games, band concerts, training camps, and horse shows. This exchange between the fort and the surrounding communities also posed challenges: in 1935 the fort's marshal reported that "a number of women" in Burlington had become "a menace." The city's matron of police quickly apprehended them.

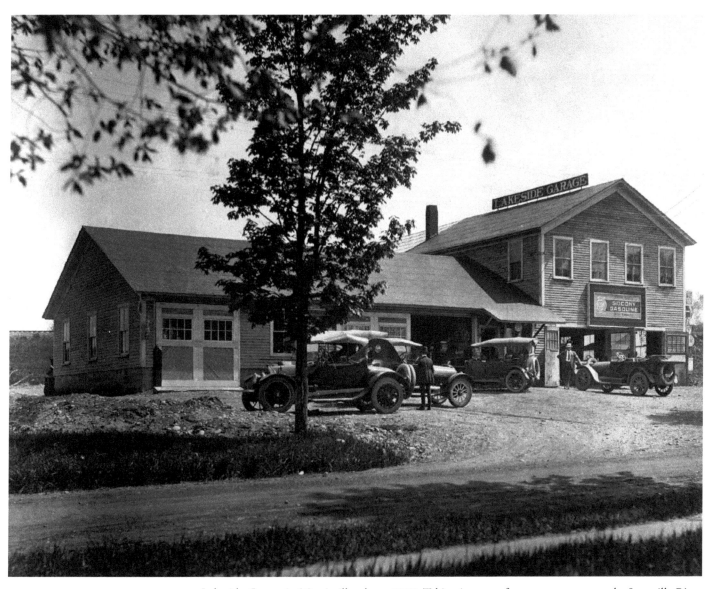

Lakeside Garage in Morrisville, about 1919. Taking its name from a resort area on the Lamoille River called "Lake Lamoille," the Lakeside Garage opened in 1916 under the proprietorship of James Reed and Fred Peck. Reed, a machinist by trade, bought out Peck within two years, and Peck entered the lumber business. The garage operated as a service and repair station for 25 years, becoming a Ford dealership in the 1950s.

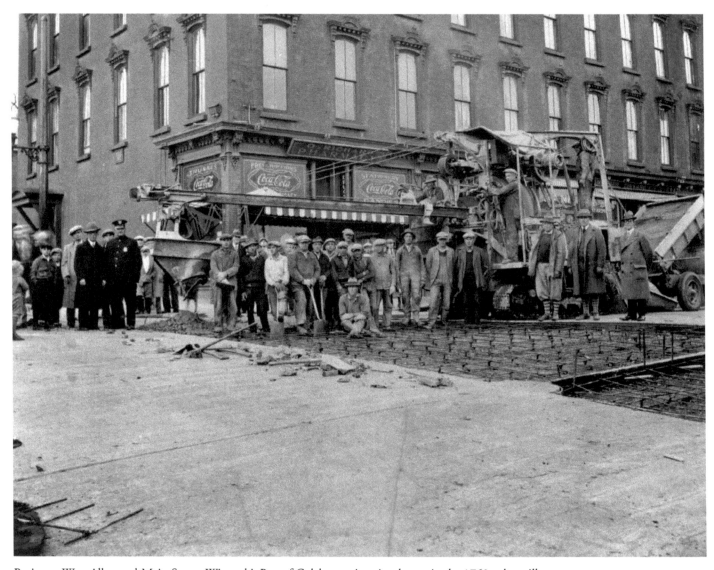

Paving at West Allen and Main Street, Winooski. Part of Colchester since its charter in the 1760s, the mill-driven, multi-ethnic area of Winooski was home to more people than rural Colchester. In 1921, Winooski split completely from Colchester, making it nearly the last city to incorporate in Vermont. Winooski residents quickly embraced a number of urban improvements—including creating police and fire departments and paving the streets.

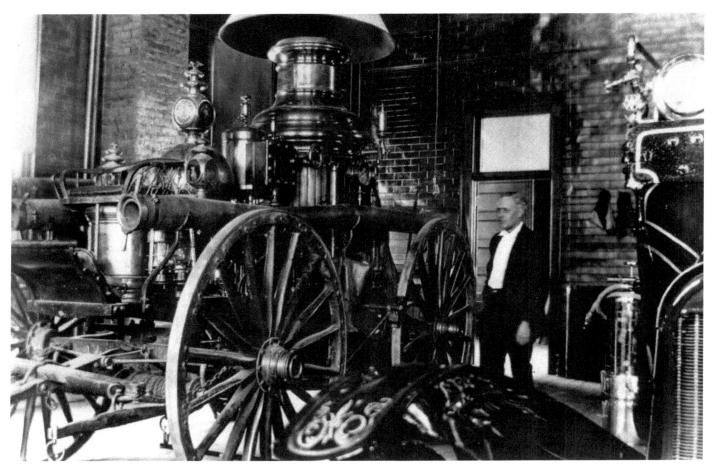

Steam pumper at the Old Fire Station in Winooski. When Winooski was incorporated in 1921, residents quickly built an infrastructure that included a municipal fire department. It was during these years that cities around the nation benefited from the prevention efforts driven by national insurance organizations. These efforts included formalized building and zoning codes, advocacy for sprinkler systems, and rules to govern modern—and sometimes dangerous—conveniences like electricity and fuel.

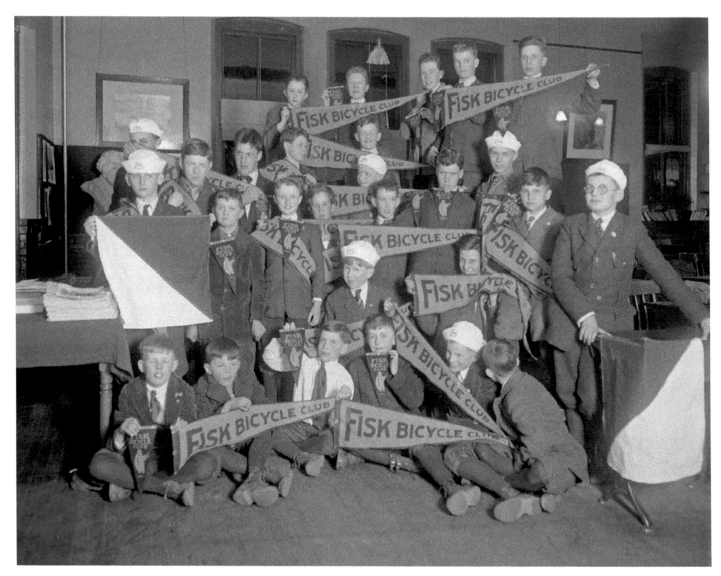

The Fisk Tire Company opened around 1900 near Springfield, Massachusetts. The company was a motivated marketer, enlisting Norman Rockwell to illustrate advertisements. It also initiated a bicycle club that became popular among boys. The Fisk Tire boy, a company mascot, appears on the banners in this photograph: a pajama-clad youth sporting a tire on one shoulder and a candle in the hand opposite, with the slogan "Time to Re-Tire" written underneath.

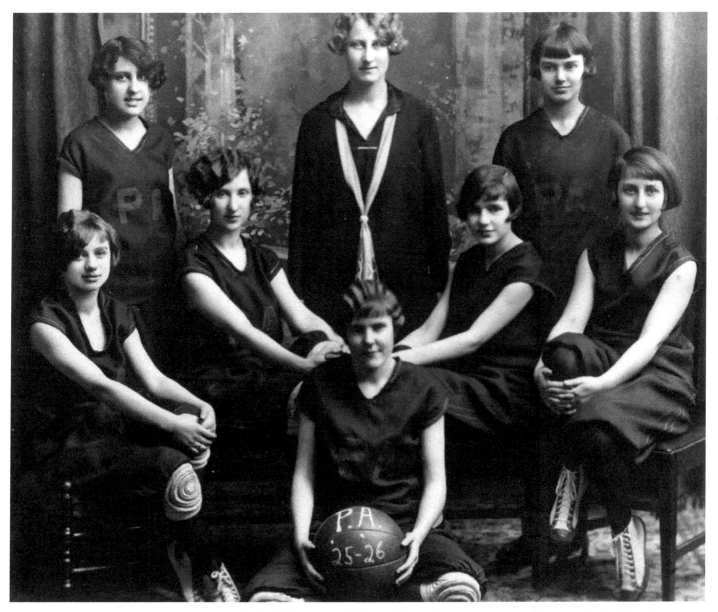

Girls' basketball at Morrisville's People's Academy, 1925. Invented in 1891 (originally using a soccer ball) by James Naismith, basketball was the stomping ground for nineteenth-century discussions of morality and decorum. One advocate urged that basketball remedied the woman's "inability to leave the personal element out of thought or action," because "it is impossible to pose in basketball."

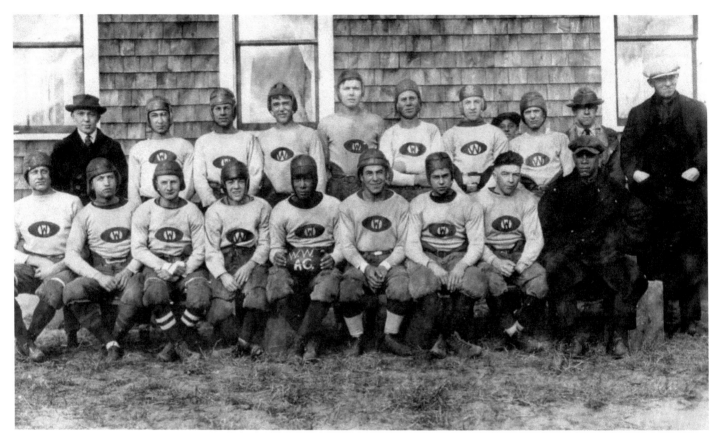

The Winooski Whirlwinds around 1924. Winooski did not have its own football team until 1931. Before that year, city residents and high school students joined forces to play for teams like the Whirlwinds. This photograph also suggests Winooski's cultural diversity, which by this time was home to Americans of varying descent, including Polish, Irish, African, and especially French Canadian.

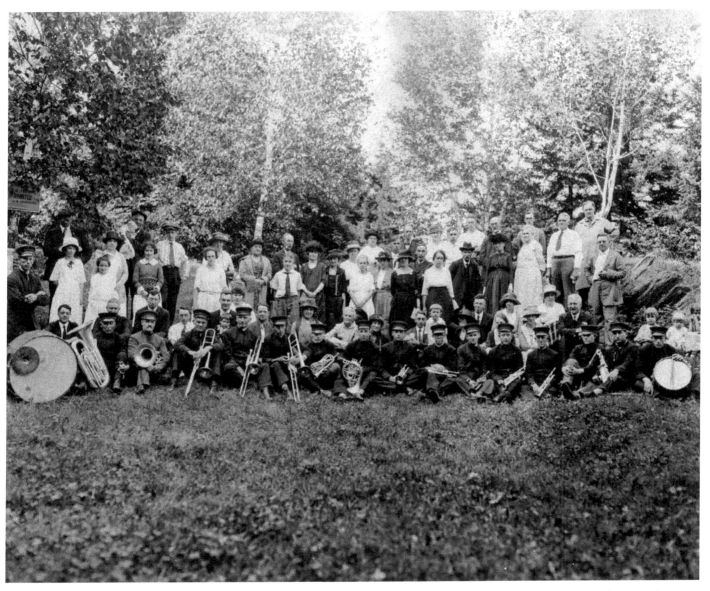

Randolph's Green Mountain Band, around 1923. Between 1900 and 1910, the number of town and touring bands in the United States peaked. Town bands grew less popular once other diversions—automobiling, the phonograph, motion pictures, and radio broadcasts—became available. After 1920, the number of these bands dwindled, many consolidating into regional groups.

A farmer and his son keep bees in Bennington. Starting in the late nineteenth century, many Vermont farmers adopted a more scientific approach to agriculture. They gleaned advanced methods from the Vermont State Agricultural Society, agricultural fairs, grange organizations, and the University of Vermont. More than just competitive advantage, one pamphlet suggested that the new scientific farming offered an added benefit: a "mental culture" for young people who sought more than "mere physical drudgery." These two brave apiarists appear to be handling a slat of live bees without wearing protective gear and without having annoyed even one of the stinging creatures. Must be the scientific approach.

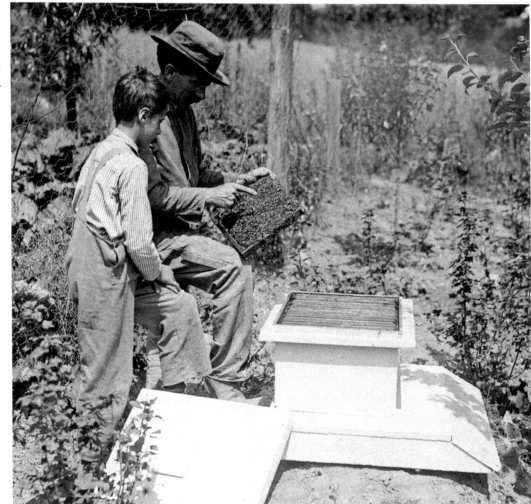

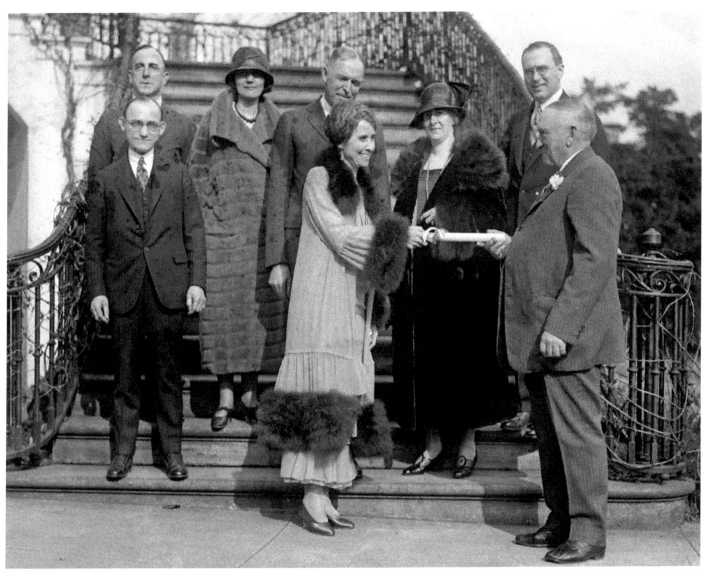

During the early twentieth century, some resourceful Vermonters raised mink and fox for their valuable furs. One mink ranch in Jericho started with two female minks and one male, and within five years had 500 animals. This trend toward farm-raised animals contrasted with that of earlier decades, when most traders hunted animals in the wild. In this photograph, Vermont fur dealers present First Lady Grace Goodhue Coolidge with a coat in 1925.

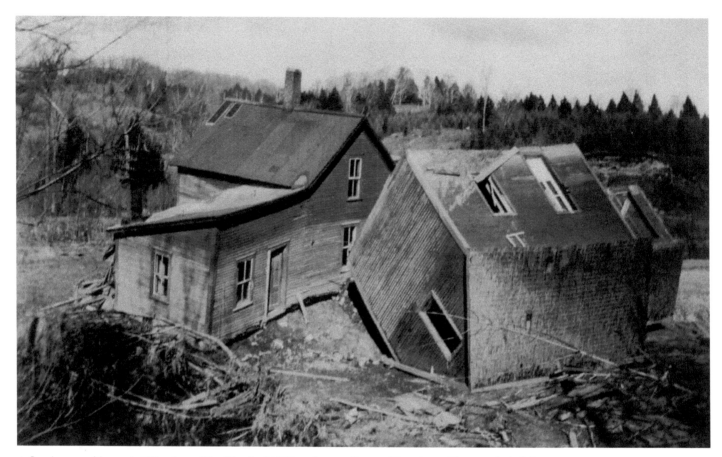

A flood-ravaged home in Waterbury. The Flood of 1927 took seven lives in Waterbury. These included the Sargent family, whose house pulled from its moorings and hastened into the floodwaters, and Gladys Cutting and her three children, who drowned when their makeshift raft of hammered-together doors capsized. Gladys's husband, Harry, who began swimming when the raft could not support his weight, survived. Neighbors found him 12 hours later in a treetop.

A Flood of Change

(1927–1949)

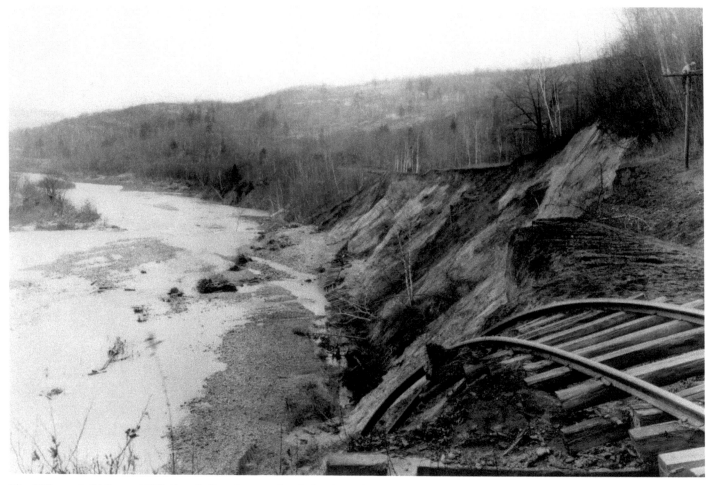

Slip Hill near Middlesex, 1927. Even before the great flood, the Central Vermont Railroad's construction department had long denounced the stretch at Slip Hill. Engines inched up the 400-foot embankment, which gave way when floodwaters blasted through. In this view, the railroad tracks linger, hanging in a garland from the eroded precipice and lying mangled along the gravel bar below. All told, the Central Vermont Railroad sustained three million 1927 dollars in flood damages.

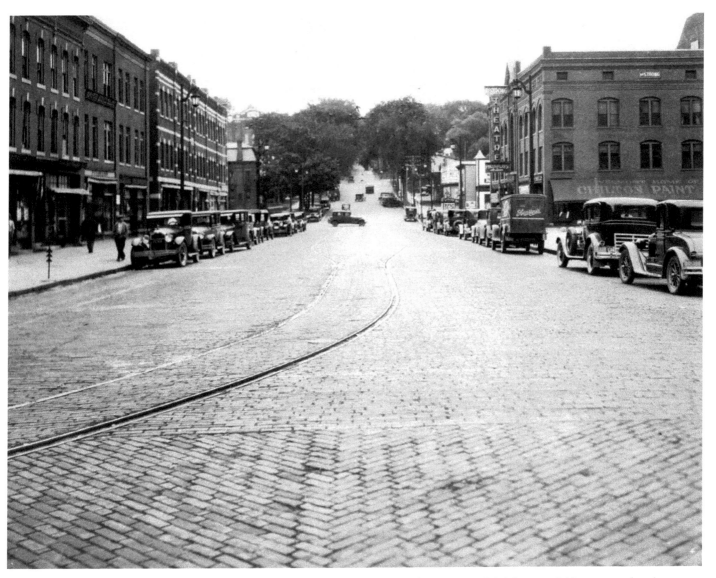

Burlington's Main Street was originally paved in 1912, with brick pavers laid over a sand-and-concrete base. In 1929, the street department replaced some of the bricks with asphalt laid over the old trolley tracks. Unlike the uneven pavers, the asphalt provided a "smooth, dustless, noiseless pavement" which was "satisfactory in every respect." The city peeled up the trolley tracks in 1943 to provide scrap metal for the war effort during World War II.

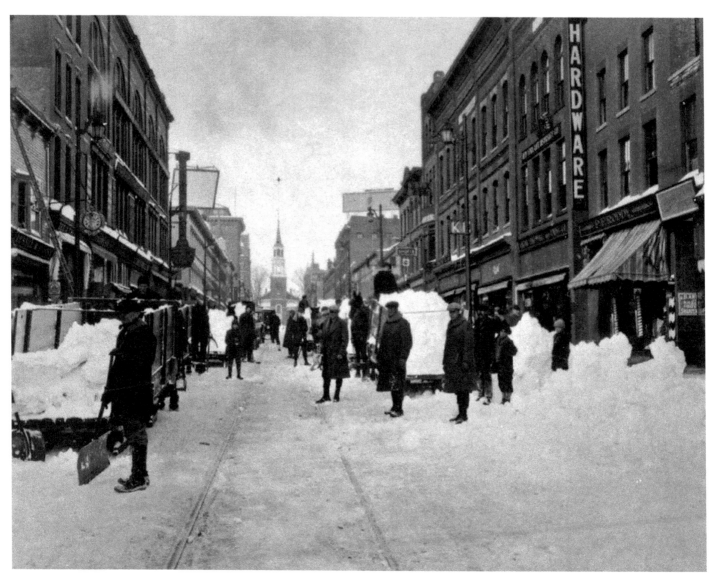

Shops on snow-covered Church Street. Shoppers from surrounding towns and states visited
Burlington, and the city endeavored to be a good host. The early twentieth century brought marked
growth of the downtown area, including shops and eventually paved streets, sewers, and sidewalks.
In 1914, Burlington City Hall even included a staffed "Rest Room," managed by the Rest Room
Association, which provided a stopping place for weary travelers and shoppers to relax before they
returned home.

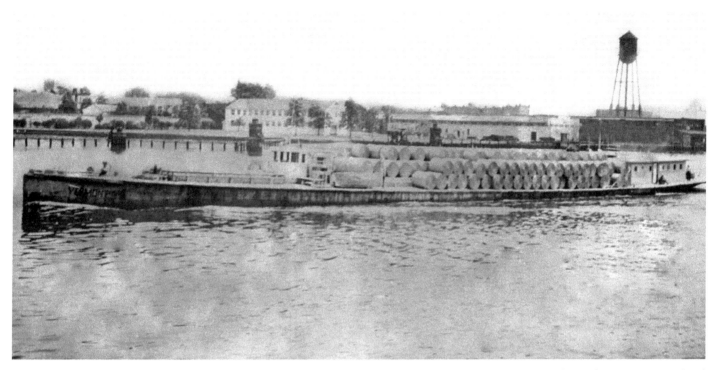

Vermont III, formerly a sidewheel steamer, was built at the Shelburne Shipyard in 1903. The palatial steamer boasted 56 crew members, including dozens of waiters, two stewardesses, a cook, pastry chef, barber, newsstand operator, and six firemen. When steamer traffic dropped off with the rising popularity of the automobile, the top decks were removed to convert the vessel into a freighter for coastal use. Here, the Vermont III carries rolls of newsprint.

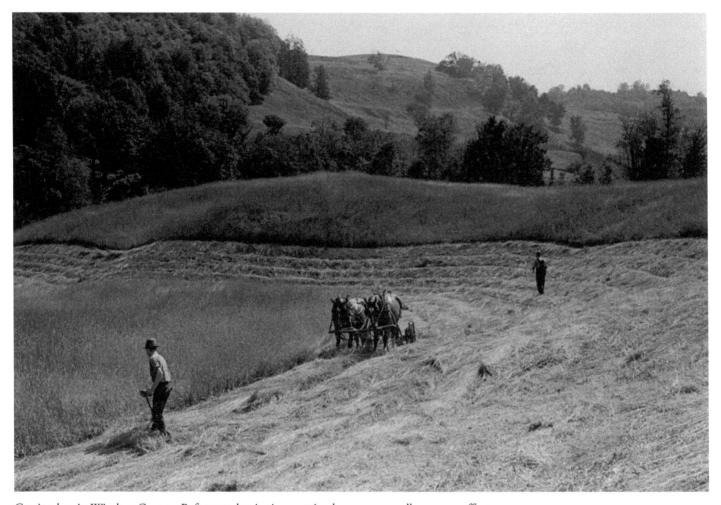

Cutting hay in Windsor County. Before mechanization, cutting hay was generally a group effort among neighboring farmers. Families enlisted their neighbors' help to finish the chore before a rainy day molded and spoiled the drying hay. For some children, the season offered a rare opportunity to visit other parts of the community.

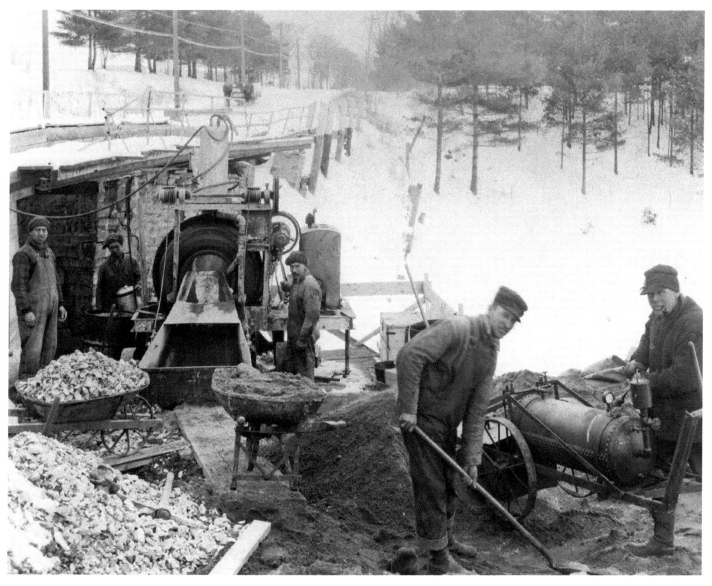

Improvements to Potash Brook Bridge on Shelburne Road, South Burlington. The street department had been paving Shelburne Road since 1921, and final improvements to this bridge helped complete the project after the 1927 flood. The crew added reinforced concrete, and the town made plans to reseed and plant small willows on the shoulders to prevent further erosion.

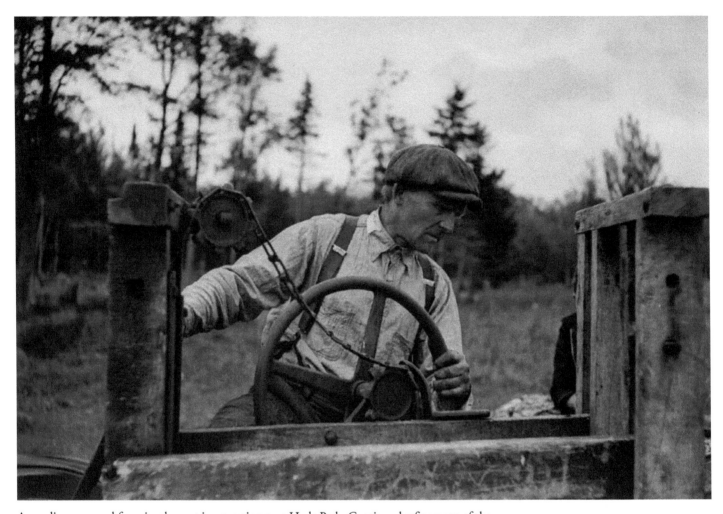

A gasoline-powered farm implement in operation near Hyde Park. Continued refinement of the automobile's internal combustion engine brought a new tool to Vermont's small-scale farmers: gasoline-powered machinery. Like the horse-powered equipment and steam-powered machinery of the nineteenth and early twentieth centuries, the gasoline-powered engine, an inexpensive and portable source of power, offered farmers an affordable way to improve productivity.

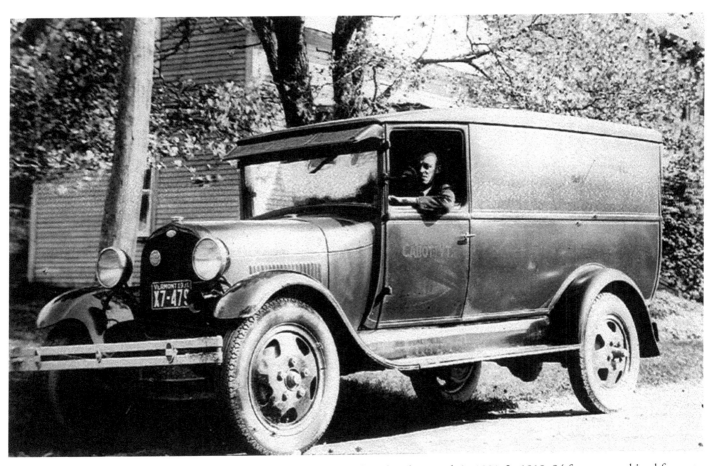

A Cabot Creamery delivery truck makes the rounds in 1931. In 1919, 94 farmers combined forces to purchase what would become the Cabot Creamery plant. Early on, the creamery produced butter for sale under the Rosedale brand. In 1930, the cooperative began making cheese.

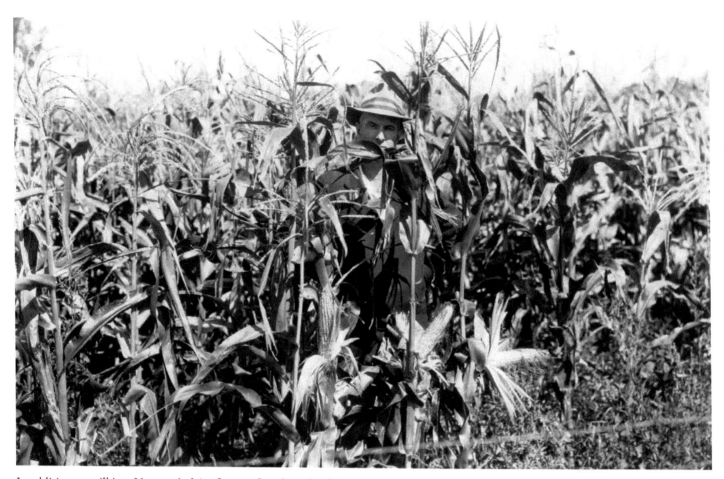

In addition to milking, Vermont's dairy farmers found much of their time occupied with another task: feeding their herds. Although sheep, the earlier mainstay of Vermont husbandry, could be left to graze, cows needed both grass and grain. Hay and corn became commonplace on any Vermont farm, and silos to store corn silage rose up across the state. This farmer poses among his silage corn at St. Albans Bay in 1932.

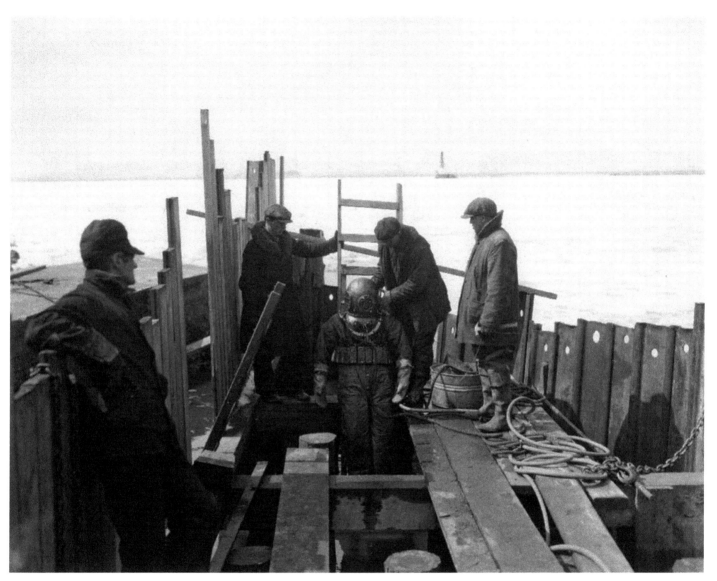

A diver works on the Burlington sewer. In 1932, Burlington undertook what city officials proudly touted as "without a doubt the largest project ever to be constructed" in the state at that time. The trunk line sewer ran down Maple Street to Lake Champlain and could reportedly handle storms equivalent to the heaviest on record—no doubt a reference to the 1927 flood. The project used 38,000 bags of cement, 24,000 bricks, and 5,000 tons of crushed stone.

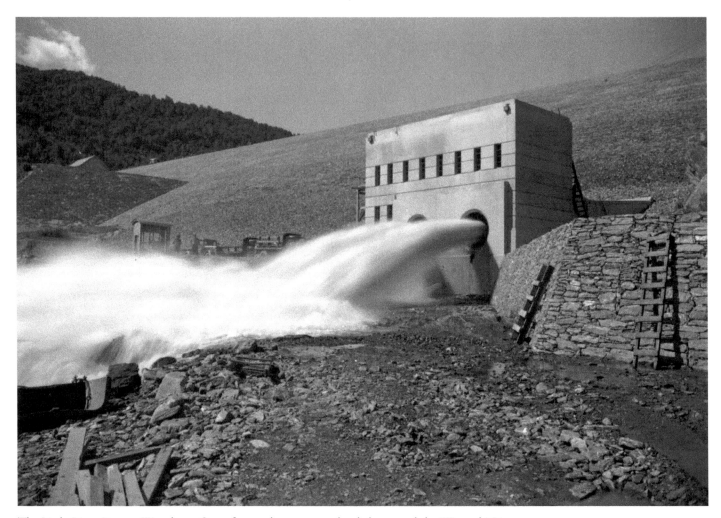

The Little River Dam at Waterbury. One of seven dams proposed to help control the Winooski River after the 1927 flood, Little River was built by the New Deal's Civilian Conservation Corps in the late 1930s. Two thousand men worked day and night in three shifts to complete the project. Eerie night scenes of men working under the lights attracted nighttime visitors to a nearby observation terrace, including President Franklin Roosevelt in August 1936.

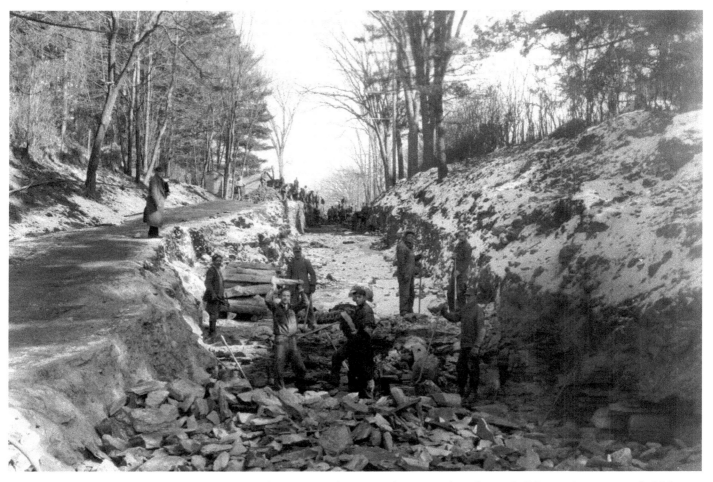

During the 1930s, Burlington took up a number of street-building projects, many of which were funded by the Works Progress Administration (later known as the Work Projects Administration). Here, the Street Department digs down seven feet during construction of Cliff Street. The workers blasted through solid rock and dug into ground frozen by the winter weather.

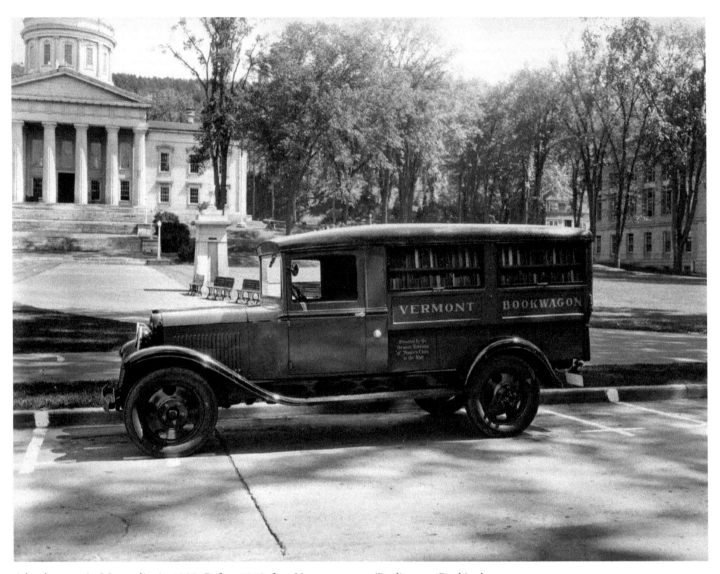

A bookwagon in Montpelier in 1932. Before 1915, four Vermont towns (Burlington, Rockingham, Fairhaven, and Morristown) received $80,000 in grants from Andrew Carnegie to construct new library buildings. Seven years later, the Federation of Women's Clubs donated the first state bookwagon. The vehicle brought books to smaller libraries and residents whose towns lacked library services. The service peaked with ten vehicles in the 1960s and was discontinued in 1974—only to be reinvigorated in the late 1990s.

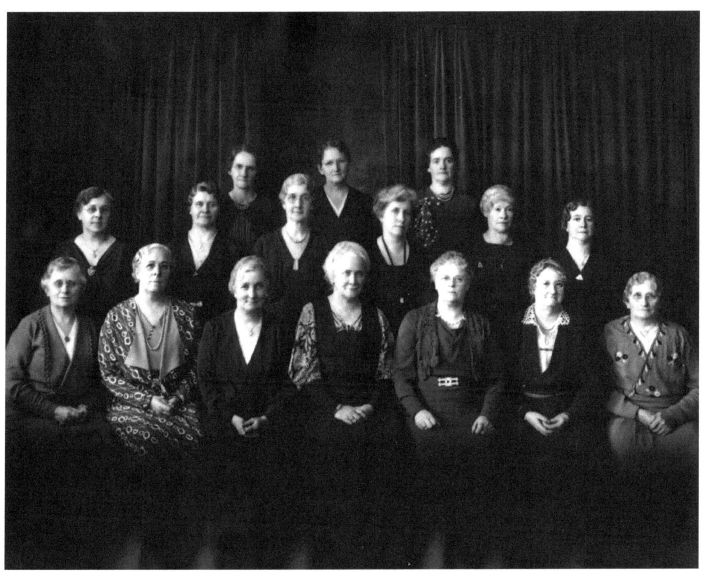

Vermont legislators in 1935. Between 1921 and 1940, women occupied 100 seats in the Vermont House and 8 seats in the Senate. The state's female legislators favored legislation relating to home and family, including investigation of adoptive families, child support for women whose husbands were injured or deceased, liability insurance for school transportation, and an allowance for sheriffs to select women as deputies.

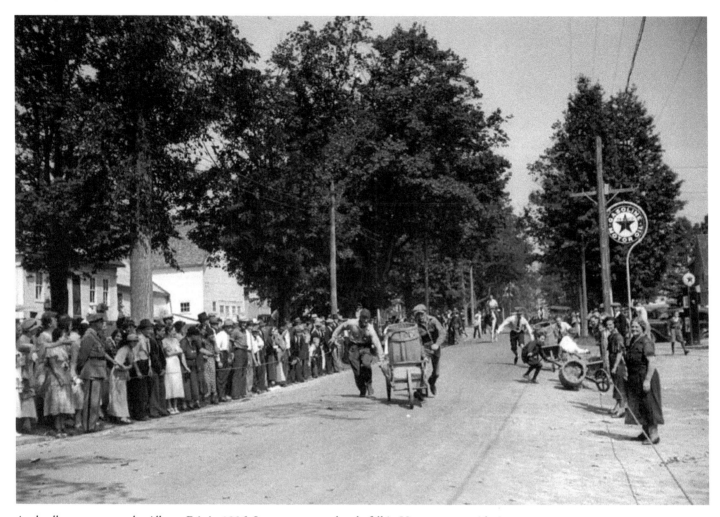

A wheelbarrow race at the Albany Fair in 1936. Late summer and early fall in Vermont mean it's time for the fair. County fairs have always been local events, complete with homegrown farm products and entertainment for and by the locals. From horseshoe-throwing competitions to peg races, the county fair is an important piece of small-town America history. The peg race required participants to tie up their horses, move off a distance, run back, harness the animal, and zip to the finish line.

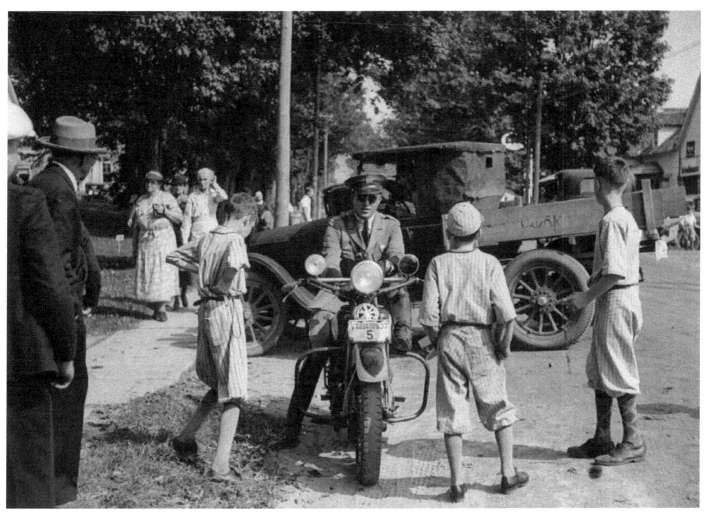

A police officer at the Albany Fair in 1936 is surrounded by young admirers. In 1918, a lone inspector, Ara Griggs, was assigned the task of enforcing laws on 15,000 miles of state highway. In 1925, the state created the Vermont Highway Patrol. Officers purchased their own motorcycles and worked only in summer, a time when out-of-state tourist vehicles represented nearly half the traffic on the road.

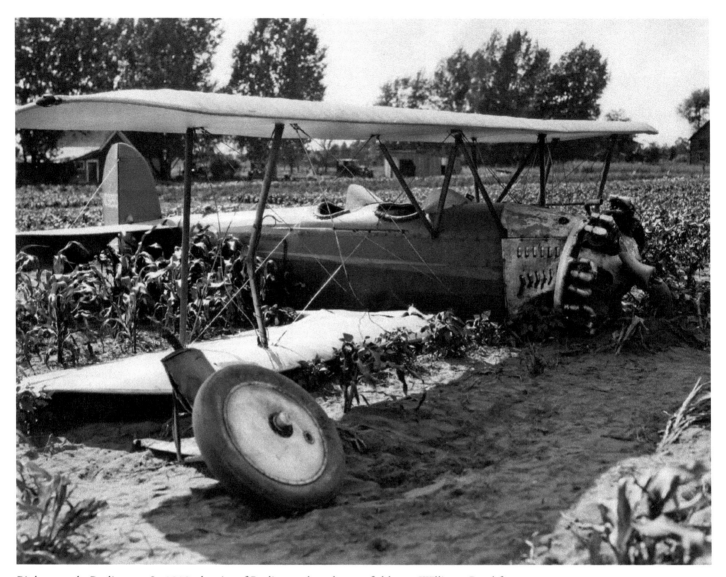

Biplane crash, Burlington. In 1919, the city of Burlington leased a cornfield near Williston Road for use as an airport, and the street department cleared a runway with a horse-drawn road grader. Grace Pugh, who in 1938 became the first woman licensed to fly in Vermont, recalled that she received her pilot's license from the Department of Motor Vehicles. At that time, no department existed for managing air transportation.

In 1931, the Burlington Municipal Airport was officially approved for commercial traffic. Arrival and departure announcements came via the railroad, and weather reports came by way of Western Union or the telephone. Often, reports turned up after planes had already taken off. In 1942, the airport adopted an air traffic control system: controllers stood on the open roof and directed incoming planes with a light in one hand and a microphone in the other.

In October 1776, Philadelphia sank to the bottom of Lake Champlain during a battle near Valcour Island. In 1935, a salvage team found the vessel with its mast still standing and a cannonball lodged in its hull. Spectators watched the recovery operation, and the Burlington Free Press asked a descendant of Benedict Arnold to comment on the occasion. The vessel is now on display at the Smithsonian Institution.

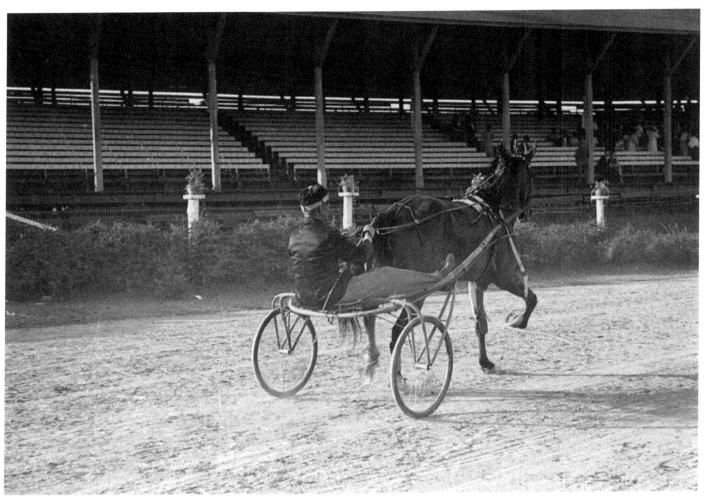

A harness race contestant at the Vermont State Fair in Rutland, 1937. When horse races first visited Vermont fairs, some worried that the excitement distracted onlookers from the event's more noble intent: to display the finest breeds to Vermont's farmers. Vermont's fairs also provided "edutainment" by showcasing other dramatic new technologies—among them bicycle races in the 1880s and a hot-air balloon launch in 1909.

An Arthur Rothstein view of the Craftsbury Fair, 1937. Rothstein worked for Franklin Roosevelt's Resettlement Administration, a New Deal program aimed at relocating farmers from unproductive lands slated for rehabilitation by the federal government. Despite support for the program from other constituents, state representative George Aiken vehemently opposed it, maintaining that Vermont should remain in charge of its own resources.

In 1937, Kirby farmboy Bob McNally demonstrates how to control a bull using a nose ring. By 1930, the state of Vermont hosted 450 active 4-H Clubs, a national organization intended to keep young people engaged in farming by way of club meetings, competitions, and affordable summer camps. Combined with the University of Vermont's Extension Service and traveling agriculture exhibits, 4-H represented state government's increasing role in supporting its farmers.

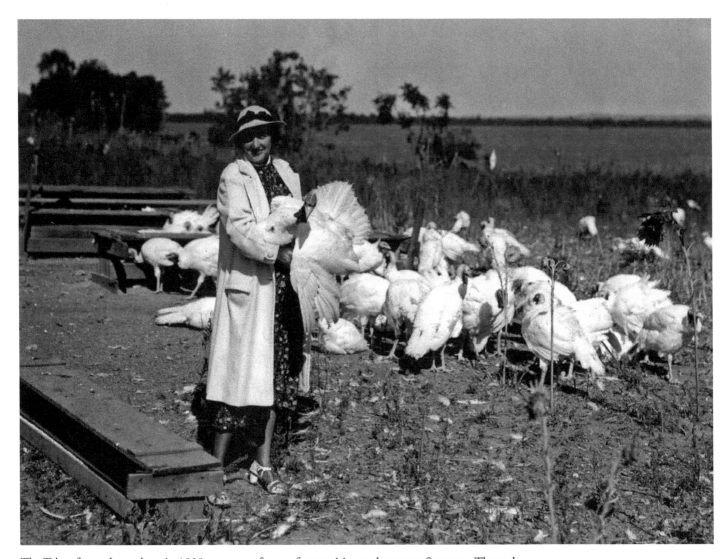

The Tabor farm, shown here in 1938, was one of many farms raising turkeys near Swanton. Through hard work and initiative, the Tabors took their family farm from a subsistence-level enterprise to a large-scale operation, rising from 3 birds to breeding more than 25,000. The farms shipped live turkeys to Boston and New York. By the 1970s the federal government had begun requiring farmers to slaughter out-of-state shipments in government-inspected slaughterhouses, putting Swanton's turkey farms out of business.

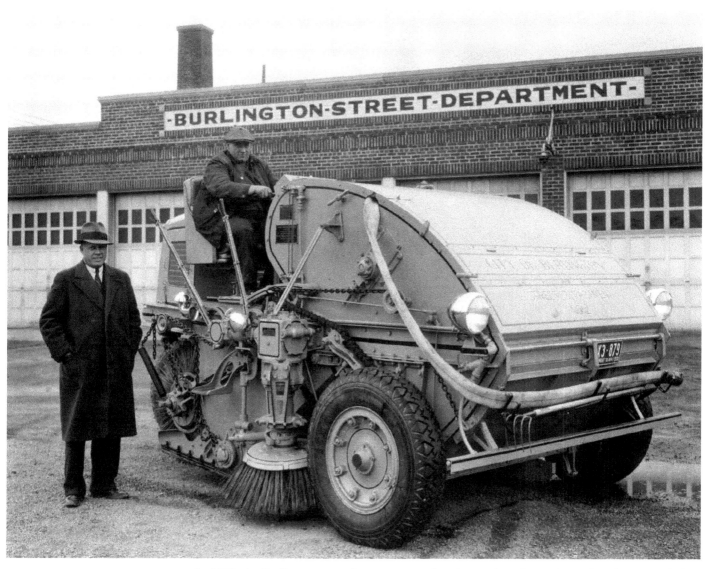

In 1937, the Burlington street department purchased a number of new pieces of machinery, including a sewer cleaning machine and a Sargent Heavy-Duty-Truck-Blade snowplow. Here, city employees pose with the new Elgin street sweeper, which the city bought for just over $6,700. Much of this new street equipment was used to keep the roads as passable in the winter months as they were in the summer.

After a storm in Brattleboro, 1940. By March 1940, winter storms had left more snow than usual on the East Coast. Newfane postponed its town meeting owing to laborious travel conditions, and the storm took five lives as it moved up the Atlantic Seaboard. Brattleboro's newspaper anxiously speculated about the possibility of spring flooding—perhaps because of a concurrent investigation into the causes of a springtime flood four years earlier, in March 1936.

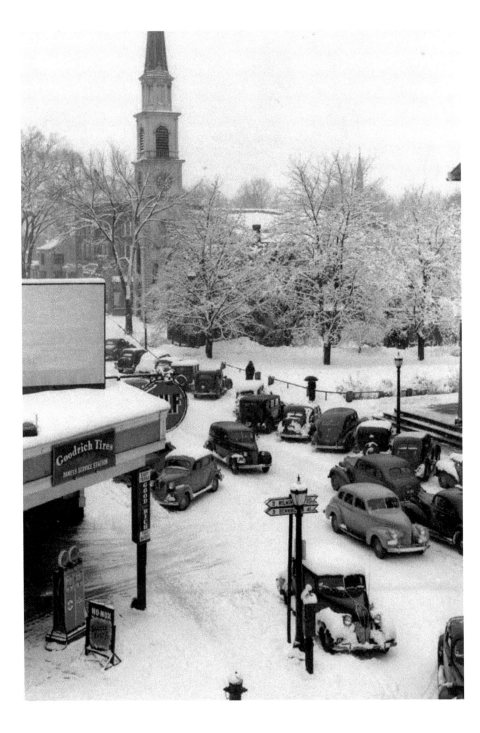

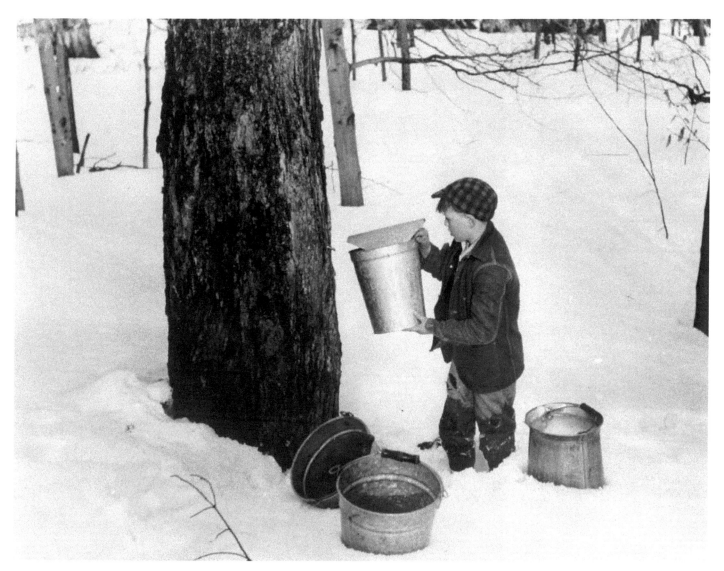

Frank Shurtleff's son collects sap on their 400-acre North Bridgewater farm in 1940. A family effort kept the farm running, and maple syrup production was one of the roles that farm youngsters could help fill. Children helped with many other farm chores. One Vermont farmer recalled how as a child he had lugged pails of water to the farmhouse, learning quickly the difference between heavy "wash days" and lighter "baking days."

Vermont marble sculptors carve a replacement statue of Ethan Allen for Montpelier's State House in 1941. Beginning in the late nineteenth century, Vermonters revived their love for Revolution-era heroes with grand monuments and statues. In 1861, Civil War artist and Brattleboro sculptor Larkin G. Mead, Jr., completed a statue of Ethan Allen for the new State House in Montpelier. The statue was replaced with this one, credited to Rutland resident Aristide Piccini.

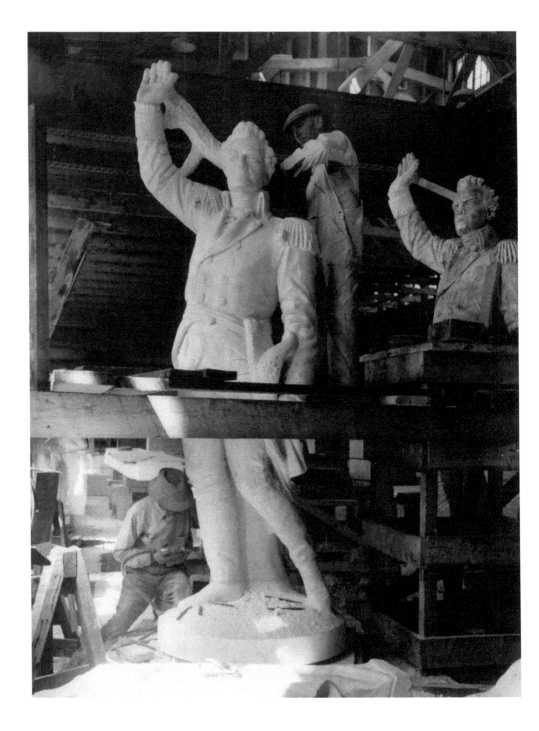

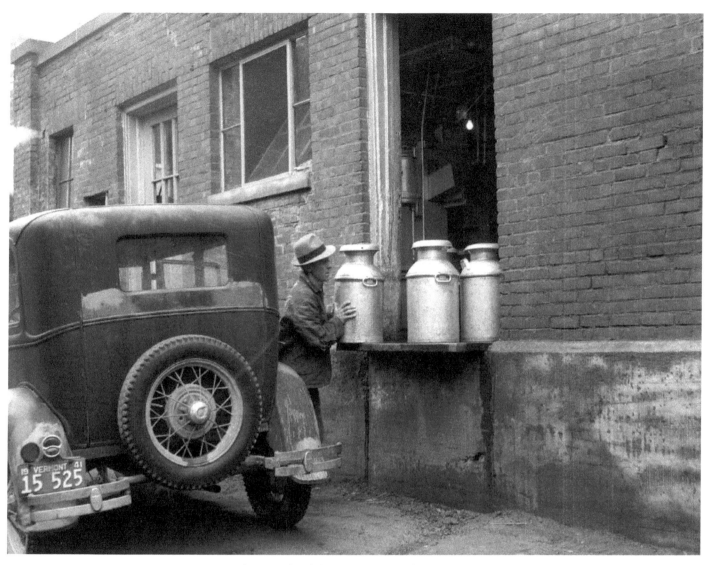

For farmers who did not live near a railroad depot, the journey from farm to railroad could prove costly since the milk could sour before it reached the train station. This was particularly worrisome in the days when milk was delivered by horse and wagon—and a problem greatly relieved by the advent of the speedier automobile. This farmer is bringing his milk to Burlington's cooperative bottling plant in 1941.

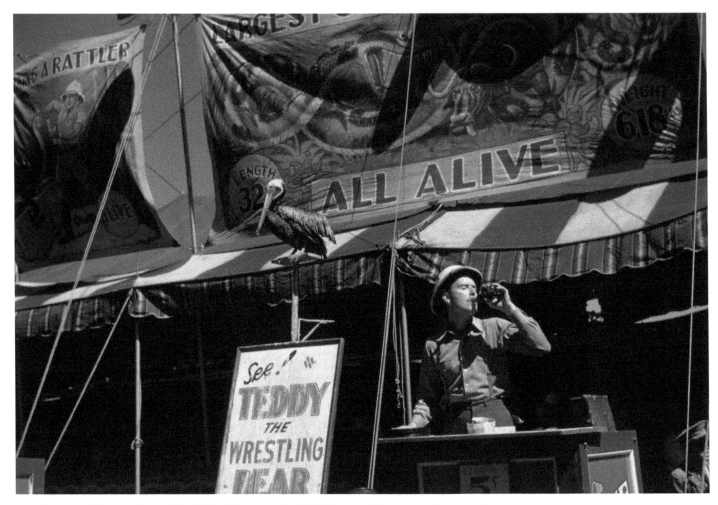

A barker at the Vermont State Fair, 1941. After stints in Middlebury and Castleton, the state fair moved to Rutland in 1852. Although its beginnings were agricultural, by the 1940s the fair had added a midway and carnival rides to satisfy the growing nonfarm crowds. In modern times, fairs have shifted away from educating farmers and toward educating the public about
arming—an eye-opening experience for those of us who think that food comes from the grocery store.

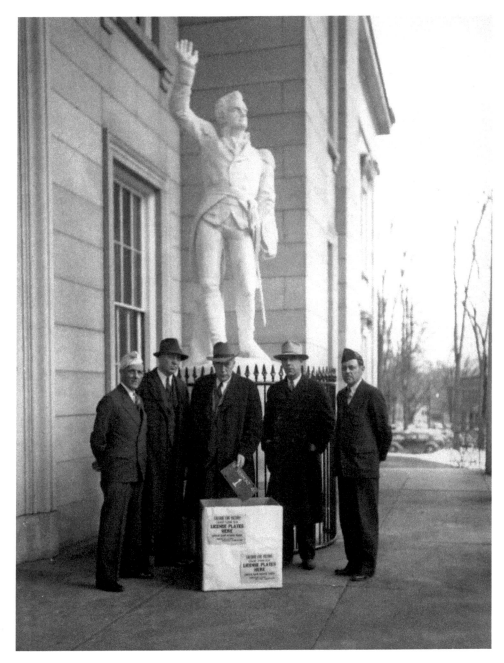

Vermont issued its first license plates in 1905 and established a Department of Motor Vehicles 22 years later. Drivers received new plates every year. Each year's plate was distinguished initially by color, and later by date. During World War II, plates were updated by attaching only a small metal tab to the previous year's plate, a result of the metal shortage. The tabs were made from the tin cans of state prisoners' food.

Milk bottling plant in Burlington. Patented milk bottles appeared by the 1880s, and by the 1910s there was talk of "single-service paper containers" for milk. The containers would eliminate the challenges of cleaning the bottles, sometimes reused by the public to store vinegar, gasoline, or kerosene. Cartons appeared on store shelves in the 1930s, but most home delivery continued to rely on glass bottles for years to come.

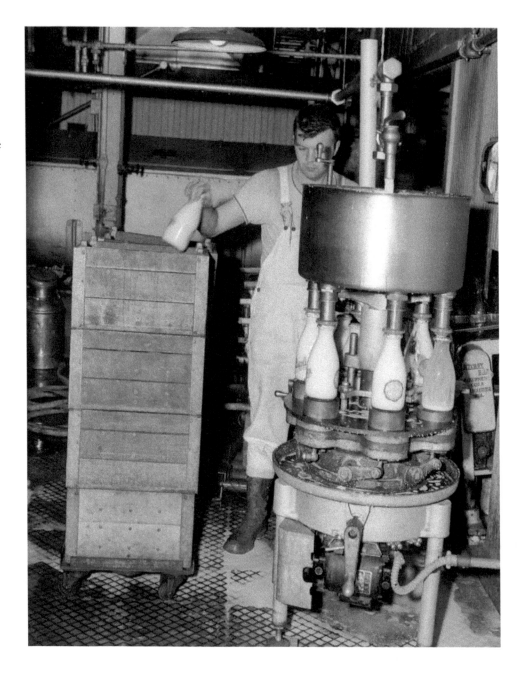

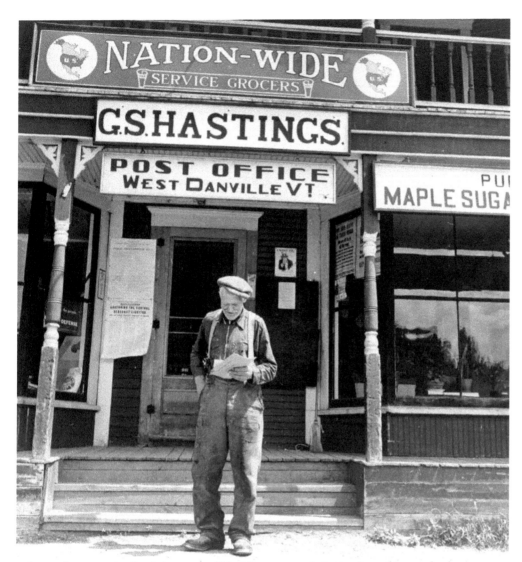

West Danville farmer Frank Goss stands reading a postcard in 1942. The postcard announced that last year's hired hand "won't be around for haying this year on account of he's in Californi' in the Navy." Since the mid–nineteenth century, Vermonters had felt the exodus of native-born sons to other states with more economic opportunity. Farms were particularly hard hit during World War II as America's finest headed abroad to defend the homeland.

Hastings General Store, West Danville, 1942. When modernity visited Vermont's general stores, proprietors swapped their long counters for self-service shelves. The day Gilbert Hastings stocked his first case of commercially produced bread, he fretted that nobody would want it. To persuade customers to buy the product, he decided to put a whistle in every loaf. The idea worked: every kid in town wanted the bread so he or she could tweet a whistle.

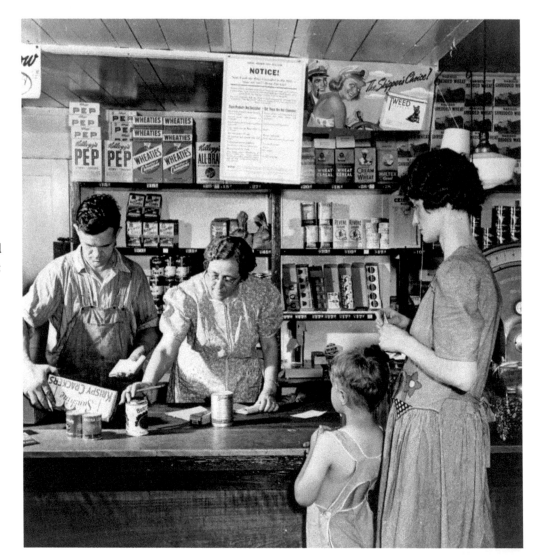

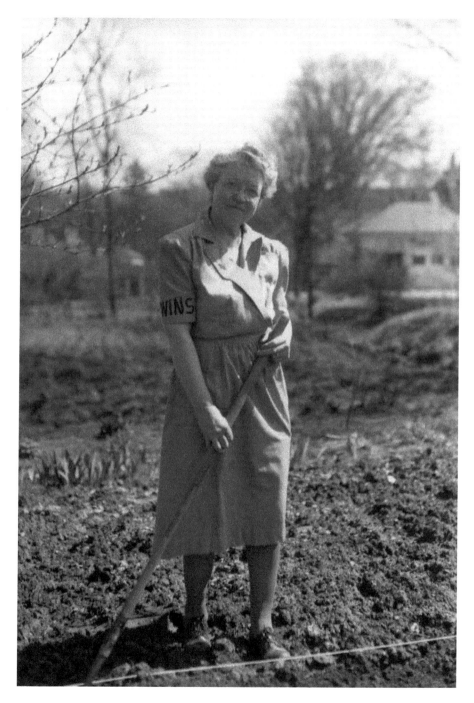

Helen Wills, wife of governor William Wills, tends a World War II Victory Garden. Reflecting on the war years, Mrs. Wills noted that "careful management in husbanding resources brought substantial surpluses for those days." Her husband worked hard to attract Vermont veterans back after the war, instituting the Soldier's Bonus and a spate of state-sponsored jobs for returning servicemen.

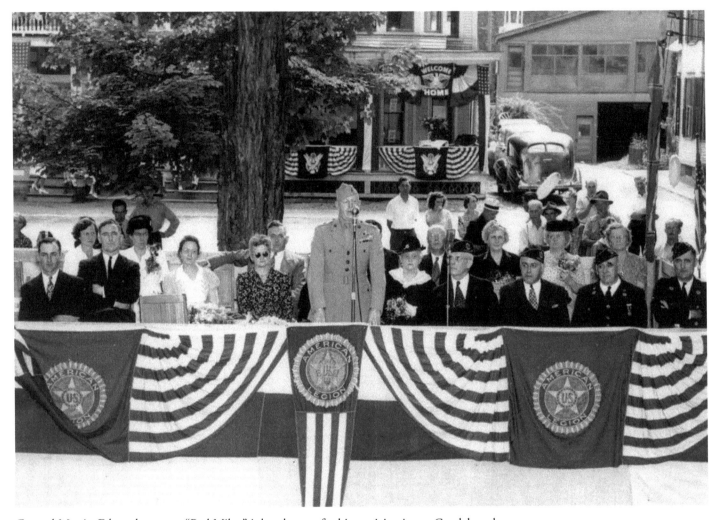

General Merritt Edson, known as "Red Mike," is best known for his participation at Guadalcanal during World War II. The only Vermonter to win the Medal of Honor during the war, Edson became Vermont's first public safety commissioner in 1947. He arrived to find troopers working 90-hour weeks and requested that the state double the size of the force. Vermonters celebrated Edson's no-nonsense manner—he once used his own car to chase down a young speeder—but they also questioned the spending increases associated with a state police force. In this image, Edson is speaking to a crowd at Winchester in 1944.

Following World War II, the solid economic footing of many Vermonters allowed them to purchase small pleasure boats. The development of reliable, inexpensive outboard motors permitted almost anyone to purchase a small runabout for recreational use upon the state's hundreds of lakes and ponds. With more people on the water, the state increased its involvement in water resource management by increasing the number of fish and game wardens and state police on the state's waters. This is a water's-edge view in Groton State Park.

Ski enthusiasts built a rope tow on Clinton Gilbert's farm near Woodstock in 1934. Constructed with 1,800 feet of rope and a Ford Model T engine, the tow attracted more skiers, who supplemented Gilbert's farming income by 25 percent. Named the "Ski Way," the mechanism is said to have spurred the rope-tow era in the United States.

From its inception, Vermont's house of representatives had instituted a system of "one-town, one-vote" representation regardless of a town's population. This system resulted in a disproportionate number of farmer-politicians pushing legislation geared to rural interests. Although industrial and urban interests dominated senatorial representation, the U.S. Supreme Court ruled in 1965 that the traditional one-town, onevote system did not appropriately represent Vermont's voters, and the system was immediately abolished.

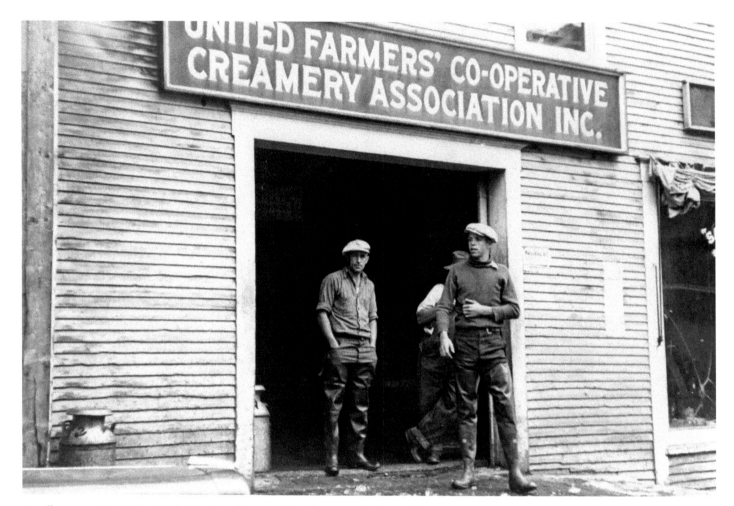

A milk cooperative in Hardwick. By 1930, Vermont dairy farms supplied two-thirds of the milk consumed in Boston. Many Vermont farmers had found themselves at a disadvantage in the Boston market, since large dealers controlled prices. In 1910, some farmers mounted an unsuccessful "milk war," holding two-fifths of the normal supply from the Boston dealers. Others formed cooperative creameries, which permitted them to ship milk themselves and to depend less on the large Boston dealers.

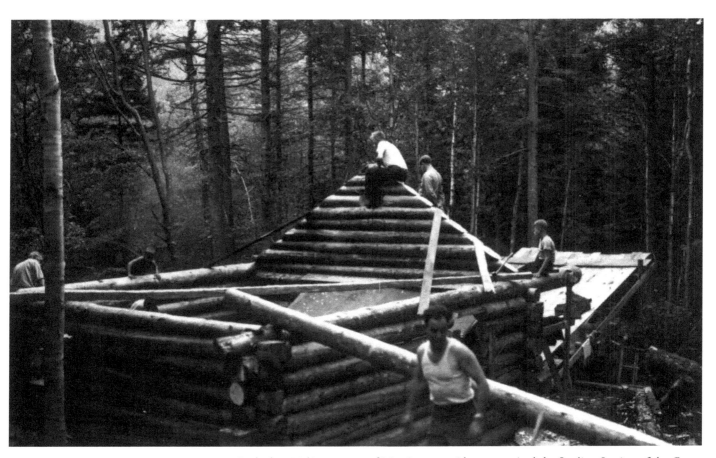

In the late 1940s, a group of Morristown residents organized the Sterling Section of the Green Mountain Club. One summer they met every Sunday to build the Beaver Meadow Lodge, a shelter that could accommodate 15 campers. A horse pulled the logs to the site, and the men dragged furnishings and a stove the two-and-a-half miles from the nearest access road. The new lodge replaced an older retreat on the trail.

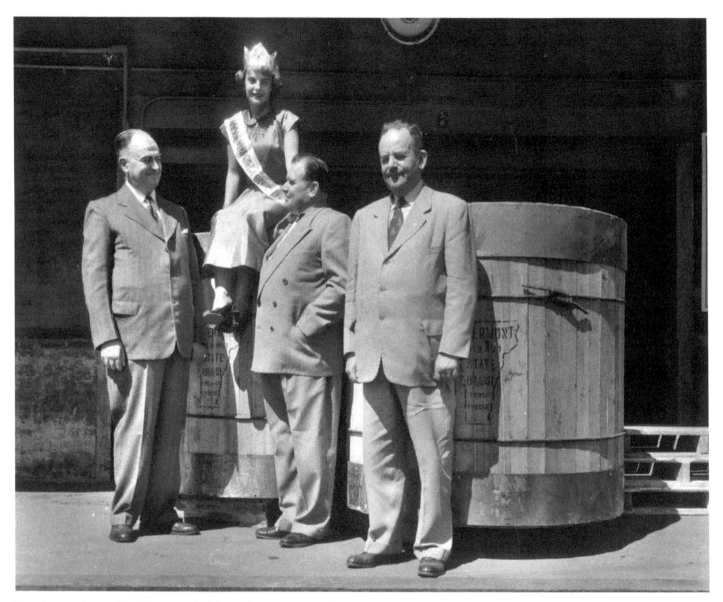

Five thousand pounds of Vermont cheddar at the Eastern States' Exposition in 1952. The exposition (the "Big E") began in Springfield, Massachusetts, in 1917 to showcase farm products and to stage competitions between producers from around New England. Employees from the Kraft Company cut the first slice of cheddar from one of these wheels, and it weighed nearly 300 pounds. Miss Vermont Dairy Queen, a young woman from Colchester, accompanied the delegation from Vermont.

THE BECKONING COUNTRY

(1950s)

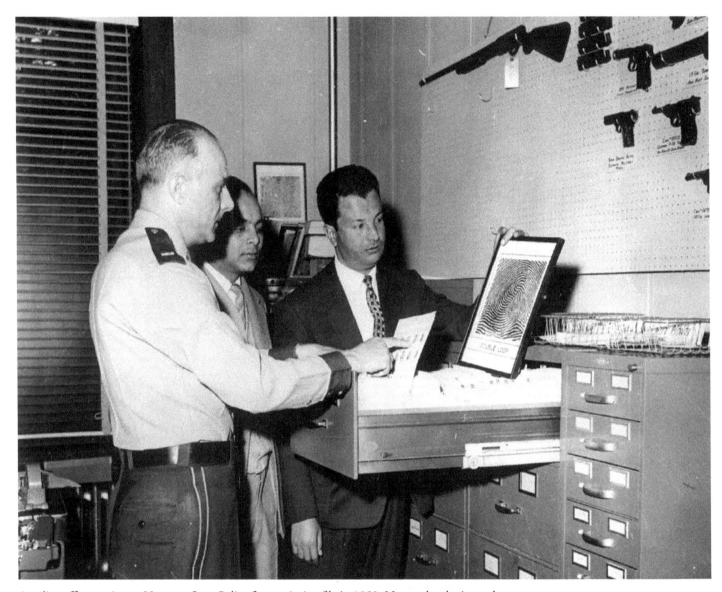

A police officer reviews a Vermont State Police fingerprinting file in 1953. New technologies such as Teletype, statewide radio, radar, and intelligence information made state police expenditures a concern to both the legislature and the public. The scrutiny was so pronounced that Governor Emerson, in office from 1951 to 1955, attempted to dissolve the newly formed state police force and fold it into the Department of Motor Vehicles.

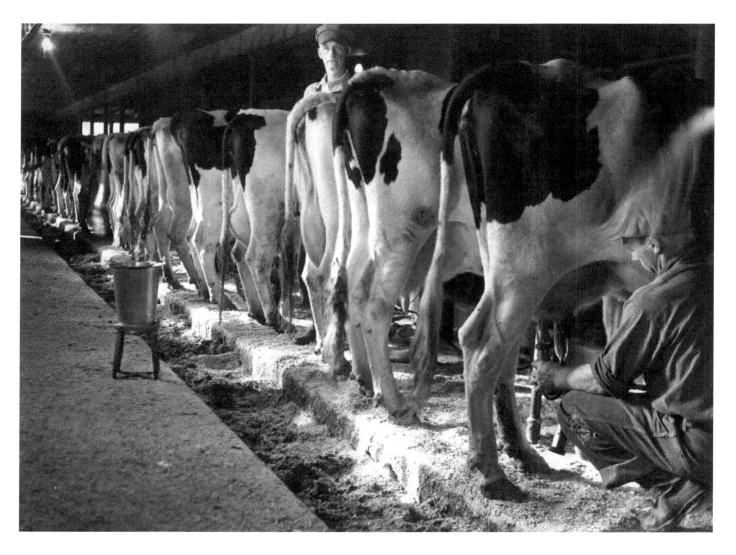

Throughout the nineteenth century and into the twentieth, a large herd for a dairy farmer consisted of roughly 20 cows. On average the farmer needed four hours daily to milk the herd. With the advent of rural electrification, farmers took advantage of milking machines and could now spend considerably less time milking. Mechanized milking machines, tractors, and automatic gutter cleaners also allowed individual farmers to increase their herd sizes to roughly 60 animals.

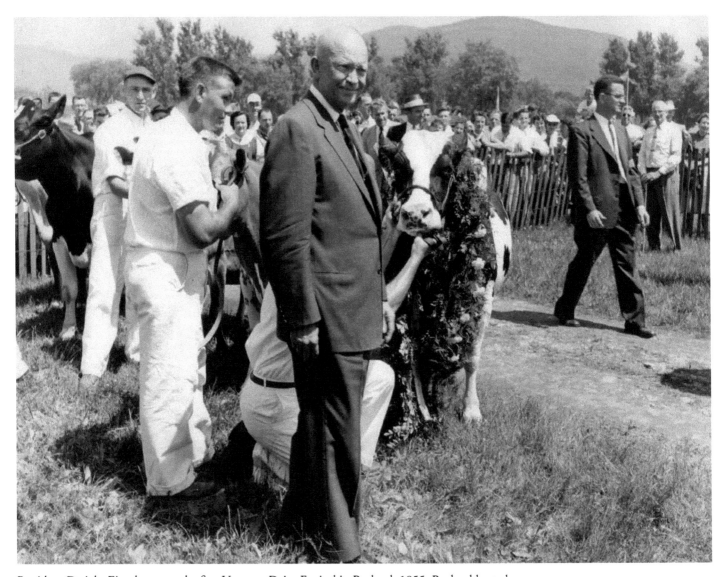

President Dwight Eisenhower at the first Vermont Dairy Festival in Rutland, 1955. Rutland hosted 50,000 visitors at this festival, to which the Rutland Herald noted that admission was free provided "you don't eat." President Eisenhower's visit was the highlight. Vermont Agriculture Commissioner Elmer Towne beat six other agriculture commissioners in the milking contest, and Eisenhower received a gift from the festival organizers when he arrived: a heifer that was shipped to his Pennsylvania farm.

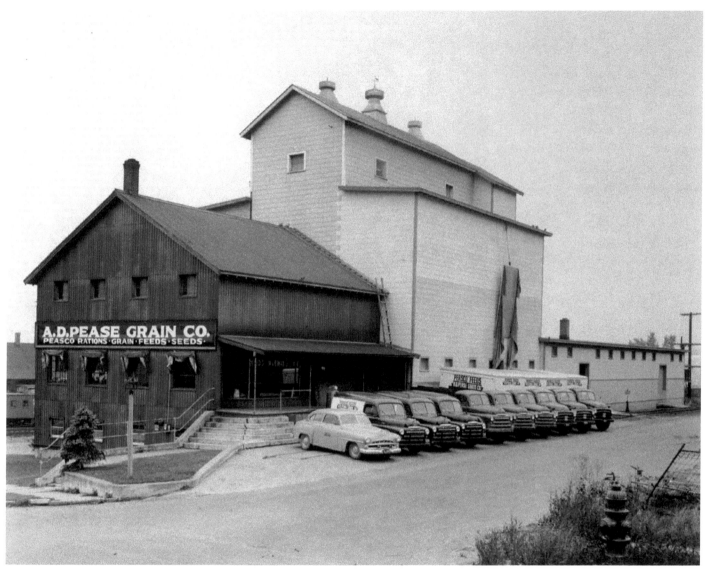

Pease Grain Company, Burlington. By the twentieth century, it had become more economical to ship livestock feed from the western United States than to produce it locally. Formerly located at 217 College Street, the Charles P. Smith Feed Company became the company of A. D. Pease around 1910. Eventually Pease Grain relocated to the corner of College and Lake streets, an advantageous location near the railroad.

After military service in Korea and Germany, including work as a World War II spy, Arlo Sterner moved to Vermont and became Lamoille County's forester. Beginning in the 1950s, Sterner employed forest management practices at the Morrisville Village Forest, a 5,400-acre municipally controlled tract of land at Green River Reservoir. The forest protected surrounding lands from flooding and erosion. Sterner's work illustrates the steadily increasing role of the state in managing Vermont's natural resources.

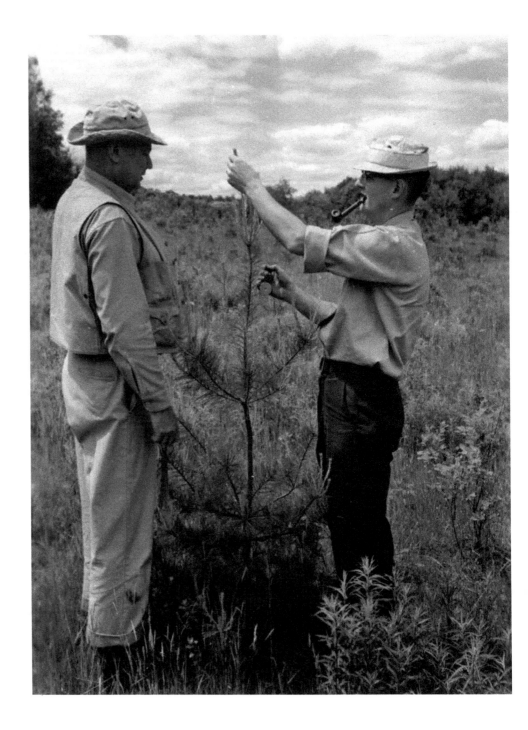

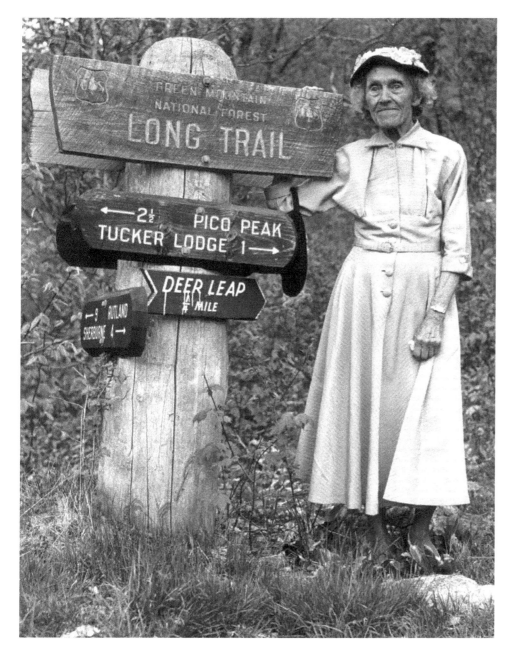

In 1910, Green Mountain Club founder James Taylor proposed a trail that could be enjoyed primarily by Vermonters. Once the trail was blazed, club members debated what colors to use for the trail markers that would be nailed to trees: the Appalachian Mountain Club recommended white, yellow, or blue markers, but discouraged red ones—while the Bennington group preferred red to all others. Volunteers donated tin can bottoms to test different marker sizes.

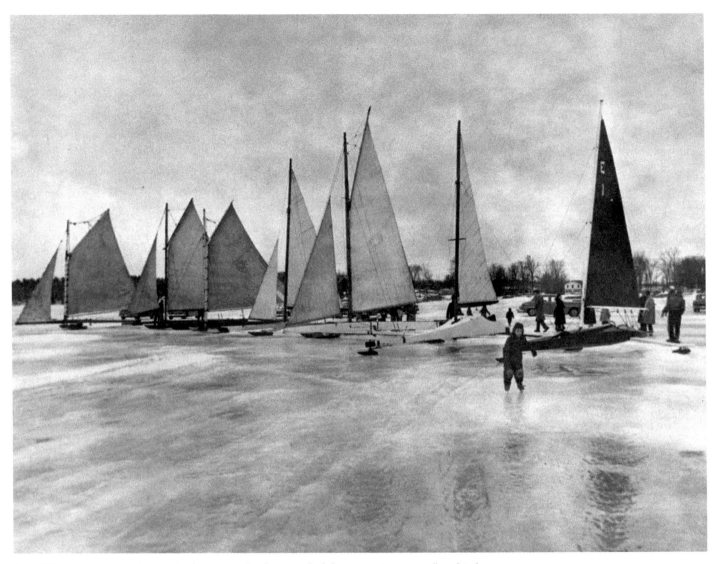

An 1881 newspaper proclaimed ice-boating to be the most "exhilarating winter sport" and Lake Champlain an "unsurpassed" venue for this pastime. Some families used iceboats for more than just pleasure sailing—fishing families transported their catch back home using the conveyance. Ice-boating clubs sprang up in the early 1900s, becoming very popular by the 1950s. In heavy winds, boat speeds can exceed 60 miles per hour.

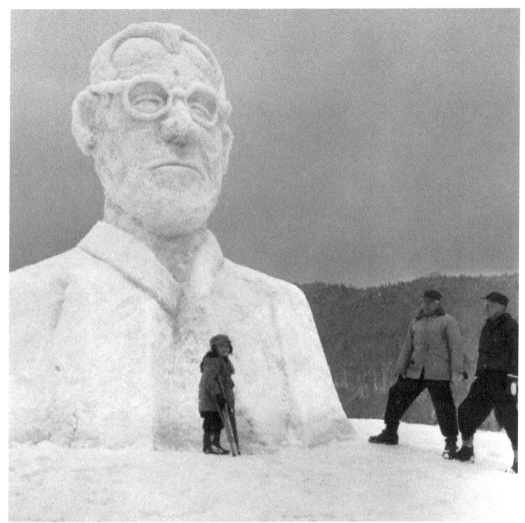

March of Dimes kickoff party on Mount Mansfield, 1956. In 1894, Vermont became the first state to experience a polio epidemic, with 132 cases diagnosed in Rutland County. The boy standing in front of the snow sculpture is the March of Dimes poster boy and the last person to contract the disease. The sculpture represents Jonas Salk, the developer of the polio vaccine in 1954.

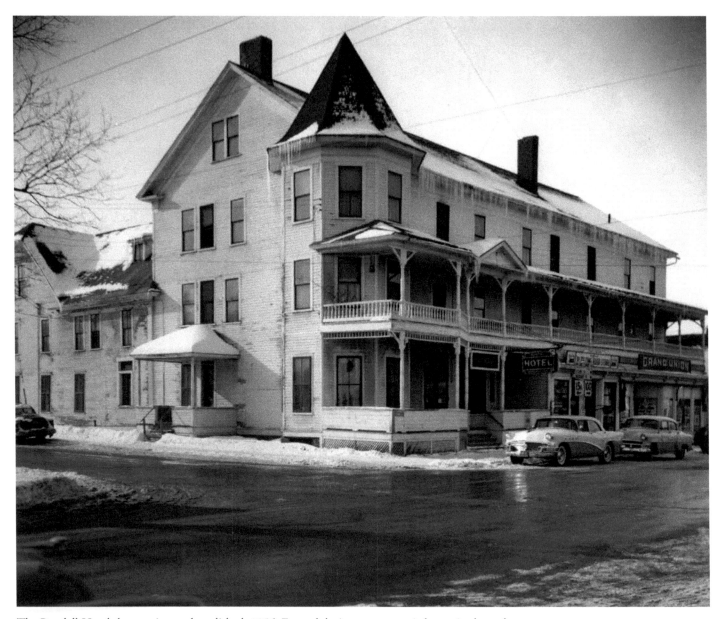

The Randall Hotel the year it was demolished, 1956. Erected during an economic boom in the early 1890s, the Randall Hotel was a centerpiece of Morrisville life. The inn served as a telephone office, celebration place for the World War I armistice, short-term living quarters for Vermont's chief justice, and the regular meeting place for the Rotary Club. Today a filling station stands on the site.

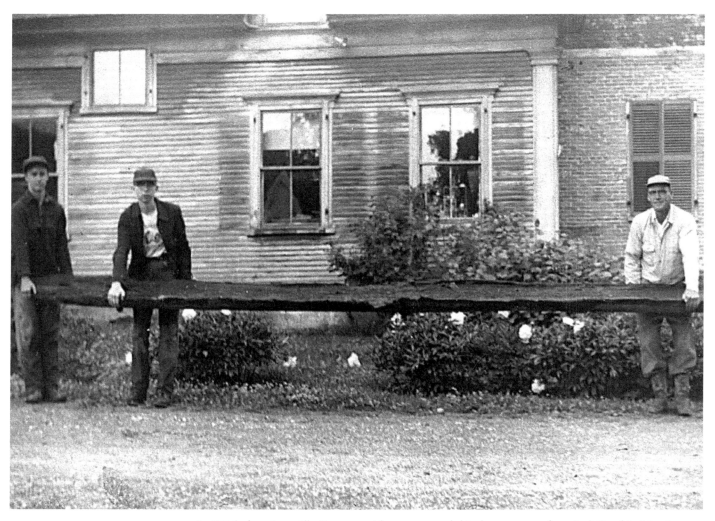

In 1956, three Lamoille County residents recovered this dugout canoe from Joe's Pond in Morristown. The vessel likely once belonged to Indian Joe and Molly, members of the Canadian Micmac who lived many years in exile in the Lamoille Valley. Joe acted as a scout during the Revolutionary War and was honored for his service by dinner with George Washington. Here the canoe is shown at Morristown's Noyes House Museum where it remains on display today.

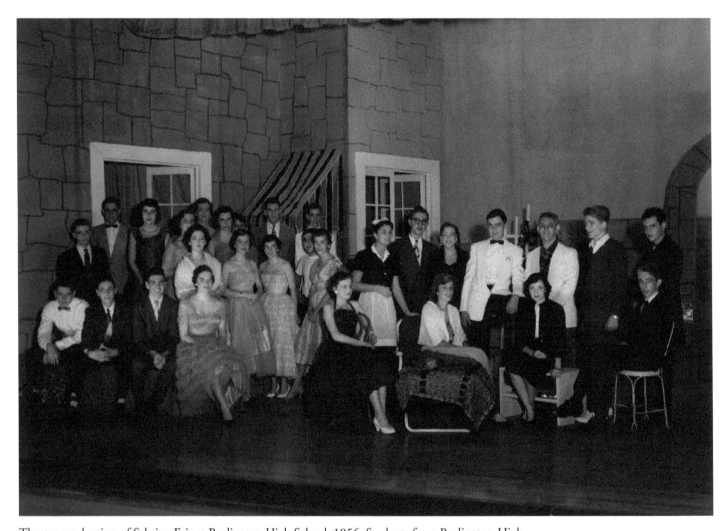

Theater production of Sabrina Fair at Burlington High School, 1956. Students from Burlington High School, located in the Edmunds building on Main Street until the 1960s, spent "many a lunch" eating ham-and-dill sandwiches at Mr. Farmer's shop on College Street. Reminiscing 50 years later, one graduate recalled how she and her friends gathered to read plays like Hedda Gabler, which she added, "I'm not sure we understood, but [we] had a great time."

Notes on the Photographs

These notes, listed by page number, attempt to include all aspects known of the photographs. Each of the photographs is identified by the page number, a title or description, photographer and collection, archive, and call or box number when applicable. Although every attempt was made to collect all data, in some cases complete data may have been unavailable due to the age and condition of some of the photographs and records.

Printed in the USA
CPSIA information can be obtained
at www.ICGtesting.com
JSHW072026140824
68134JS00042B/3800